THE
NIGHT LINE

A Memoir of Work

Text by
AMBROSE CLANCY

Photographs by
PETER M. DONAHOE

NEW AMSTERDAM
New York

Also by Ambrose Clancy
Blind Pilot

Thanks to Mary Lydon, Melanie Burrows,
Scott Rollins, Helmut Meyer, Asher Lans
and the taxi workers at Metro Systems, L.I.C., New York.

Text © Ambrose Clancy 1990

Photographs © Peter M. Donahoe 1990

Published in 1990 by
NEW AMSTERDAM BOOKS
171 Madison Avenue
New York, NY 10016

Library of Congress Cataloging-in-Publication Data

Clancy, Ambrose, 1948–
The night line : a memoir of work / text by Ambrose Clancy;
photographs by Peter M. Donahoe.
p. cm.
ISBN 0-941533-45-X
1. Taxicab drivers—New York (N.Y.) 2. Taxicab drivers—New York
(N.Y.)—Pictorial works. I. Donahoe, Peter M. II. Title.
HD8039.T162U63 1990
331.7'61388413214'097471—dc20 90-32634
CIP

Printed and bound in Hong Kong.

This book is printed on acid-free paper.

for
the fleet cab drivers
of New York City

CONTENTS

Shaping Up 7

Change of Shift 11

On the Street 13

End of Shift 35

PHOTOGRAPHS

Shaping Up 37

Change of Shift 55

On the Street 63

End of Shift 107

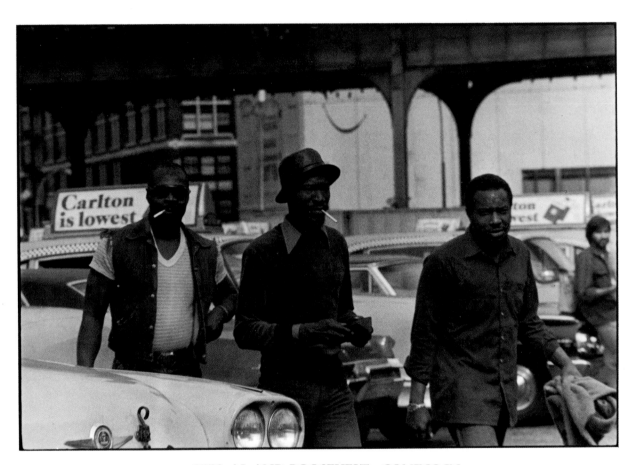

OTIS, AL AND ROOSEVELT—COMING IN

SHAPING UP

IT is an acquired skill. Not the drill of getting up, going to the garage in the early afternoon, giving your picture (hack license) to the dispatcher, taking a trip card and a set of keys when he calls your name. The skill comes between the time you put your picture in and the time you go to work. That's two, three, four hours of nothing to do, of waiting, the Modernists' metaphor for the human condition, but shaping up is no metaphor. It's two, three, four hours of time, and fleet cab drivers understand the pitiless dialectic of work better than anyone: Time is Money.

Of course you're not paid for shaping up. Of course. Go tell the union about it. That's not even good for a laugh. The union?

Only good part of the union, only *efficient* part of the union is the goon squad. Say what? You know, man, go on down to the headquarters on Park Avenue South, yeah, right across the street from where the old Bellmore used to be and check out those big slow dudes hanging around the hall. Hard-ass Italians from Red Hook, dead-eyed Irish from Inwood, wicked blacks from the Bronx, hitters who can break an arm quick, take out your legs in a second, guys who get the job done, yeah, hanging out dunking Drakes Cakes in their coffee. They don't see much action anymore. The sixties, early seventies, sure, they were the complaint department then, but now? Nobody really cares. Even the General Union Meetings have cooled down. They're still chair-throwing parties, but the goons are in total control. The union? Oh man, don't even talk to me about it. Paid for shape-up? Never happen. Those guys have it knocked. They take your money and give you nothing. Zero. *Finito.*

Two, three, four hours. Around Christmas or in the summer when college kids are working it can go five or six. The skill? The way to handle it? That's harder to pay than the nine a month off your check or the twenty cents every trip that the union and the boss split. The *time,* that's the tough one.

After working until two or three in the morning, hanging out another hour or so with a beer, counting the take, on a high of relief, fatigue, over a hundred miles of street work finished, and then finding your way home and coming down from the night for another hour or two, the rest of the city as quiet as a village, falling asleep, if you're lucky, in the first position you hit the bed, flat out, dead, logging a few hours in the rack before coming back to the garage, to shape up, to get it up to do it again, to let the hours pass, that's the trick.

Hit the Greek coffee shop up the street with a friend for breakfast at two in the

afternoon. Take your time over the paper, another cup of coffee, maybe one to go before wandering back to the shape-up room.

Packed with bodies. Cigarette smoke hanging in clouds, a big place, but not big enough for up to one hundred fifty, two hundred drivers.

The room. Too hot in the summer, bone cold in the winter. Neon lights in the ceiling, a long bench along one wall, old newspapers, coffee cups and a thousand butts littering the floor, a couple of trash barrels, a soda machine that doesn't work and a cigarette machine that does, the dispatcher's elevated window at one end and a door to the garage at the other where the mechanics work on cabs in a dirty light.

Over-qualified Ph.D.'s rapping in French with a farmer just up from Haiti. A Latin American delegation in the corner bopping around a ghetto box blasting Tito Puente until some old Irish clock puncher in a flat cap, his face as gray as the streets he travels, tells them to take it outside. Four hipsters putting up cash for a reefer deal in the city later. Later, man. Actors reading *Variety* with two writers goofing on them. Other drivers in a zombie stroll, trying to wake up, walking into the gloom and noise of metal on metal of the garage, looking out at the day line rolling in, the gas boys doing their thing. Some of the gas boys are candidates for early retirement in state institutions, others are neighborhood kids, sons of immigrants, already working men at the age of fourteen.

Checking the weather, listening to the roll call of names from the dispatcher. Was that guy ahead of me? Am I getting ripped off?

Friends make it pass. Friends whom you see every day, month after month, but you only know part of them, a very small part. Even the names are partial, usually all you know is the last because you hear it from the dispatcher when a buddy is called. Some friends you never learn their names. It's just hey, man, how'd you do last night? Before you talk. Talk for hours.

Regardless of names, the friendships are firm. You never see friends except when shaping up, or if you catch one working out on the street, or after work back at the garage, and yet the friendships are solid as doors.

It is close to heartbreaking when you miss a friend for a few days and ask someone, "Hey, have you seen Monroe?"

"Who?"

"I think his name is Monroe. Or Menloe. You know?"

"No."

"That guy I hang out with? The little spacey cat with the wild hair. You know him, man. Always wears the army jacket. He was in Nam."

"Oh, yeah. I think so. Black guy?"

"No." Walk away thinking: I don't even know his name.

The talk keeps you going. Smoking dope out in the lot in the back of a cab you'll hear a discourse on pig farming between a Kentucky boy and one from Minnesota. In the shape-up room two black guys are telling an Hispanic where to get ribs on Ninth Avenue. Endless talk and equally endless lies. Some guy claims he went to

Riverhead last night, hauling some rich woman who paid him, tipped him and laid him, while his friend says, "Get the hip boots in here. It's high wide and deep."

And the storyteller responds, "No shit, man, if I'm lyin' I'm dyin'."

"Then you're stone dead. There's no rich women in *Riverhead*. I used to live out there."

More stories, all told in the cabbie style. Present tense, the tone is a mixture of defeat and defiance. "I pick up this drunk at the Waldorf. Fuckin' doorman pours him into the cab and tells me to take him to Great Neck. I *lay* into the doorman. If I'm gonna haul *your* problem away, let me see the cash. So the doorman is hot and I. . . ."

"Doorman? Don't talk to me about it. I read in the paper the other day about the head doorman at the Plaza. You see that? Yeah, it's his last day at work before he retires. He's been there fifty years or something, and he's talkin' about all the celebs he saw. You know? The Duke and Duchess of Windsor, Babe Ruth, Roosevelt, Frank Costello, King Farouk, you name it. DiMaggio. Lindbergh. Then at the end he's asked about cab drivers. Cab drivers, he says. Cab drivers are mongrels."

"Mongrels? He said mongrels?"

"It was in the *News*. This is coming from a creep who spends his whole life opening a door and kissing ass for a quarter."

"Yeah."

"Mongrels. What's he, a pedigree? Fucking jerk, man, a fucking jerk in a costume, walkin' around holding umbrellas, tipping his cap. Hello. Mr. Shit Heel. Cab, Mrs. Ball Buster?"

"Yeah."

"Some sixty-year-old goof-off, a pocket pool champion. Sneaking cigarettes."

"Yeah."

"Jackin' around the front of some building with the rest of the boys."

Or talking strategy, still present tense, "So, I'm at Kennedy. Nothin' movin', nothin'. Some assholes at TWA are jumpin' the line and I say, let me get out of here and put some money on the clock. I'm cruising Queens Boulevard and pick up two guys off work from a bar. They want Tenth Street and Second in the city. I drop them and they lay a ten on me for a seven-dollar job. Shit, I say, let me get home, when up walks this guy dressed like a cowboy and I. . . ."

Present tense, eternally. And that "let me," is it a request, a prayer, what?

The hours roll by like stones being levered from a field. A little dynamite would help, but the pole and your back are all you have to move it. It's hard empty work, day in, day out.

Some drivers play the horses to kill time. Checking with other d.j.'s (degenerate gamblers), reading charts. And within six months you're working to buy Christmas presents for the bookies' kids.

The bookie? The cashier at the coffee shop. One of the dispatchers. Both give credit, easy terms to steady patrons.

It passes the time. Sometimes a desperate soul needs more desperation to keep him going, keep him shaping up, and Aqueduct will definitely help you there.

Talk.

Take a walk. Back to the Greeks for coffee. Is it gonna rain tonight? Crack open a new deck of butts. More talk.

Sports talk. Baseball in the summer. Hockey in the winter. Cabbies are Rangers fans, screw the Islanders. Cabbies are Mets fans, screw the Yankees.

Boredom and anxiety combine to mix a dangerous drink, day in, day out.

It sours your insides, eats your patience. It burns away at your humor, your gentleness, your self-respect.

Fight it, and more likely than not, you beat it.

But what a toll the battle takes, what reserves you use up, what exhaustion you face hour after hour, day after day, week after week, by just trying to get to work to make an honest dollar.

CHANGE OF SHIFT

THE dispatcher calls the magic name and you get your trip card and keys. You're out at the gas line, looking at the hack you'll spend the next nine, ten, eleven or twelve hours in. If you're lucky you draw a good one. Very quick, very whippy with spongey brakes and a deep, soft horn. Or you're unlucky and you get a heater, a shitbox with no shocks, the day man ate his lunch all over the front seat and the horn sounds like you stepped on a frog.

Don't clean the cab there. Get the tank filled, cut up a side street to fill in your mileage on the card and then clean the cab. Near a schoolyard, a two-family-house neighborhood, trees, a view of a bridge, the sound of kids playing. And it's only then that you think about the night ahead and about the danger. Usually you don't think about it. Leave that number for your wife and family.

I've been robbed twice. Once by a junk-sick boy on Smith Street in Brooklyn right across from that big prison on the corner of Atlantic Avenue, in broad daylight, but I tell you, I failed to perceive the irony when I looked into the small black anus of his piece, thinking, he's going to shoot me dead with this trembling gun. The other time I was robbed by a slick fly worthless soul with a six-inch double-edged razor at 101st and West End. I didn't want to die. I never want to bleed to death in a taxicab late at night on a deserted street with the motor running.

Both of those near misses with Mr. D. were because I didn't know what I was doing. While you're cleaning the cab, getting yourself set, it's good to review some rules. The junkie I picked up at the Port Authority.

Rule *numero uno:* DO NOT PLAY THE PORT AUTHORITY. That's where the International Brotherhood of Muggers, Loons and Assholes shape up for work.

Numero dos: DO NOT PICK UP PIMPS, OR PERSONS ATTEMPTING TO BE PIMPS. Pimps will have you drive all over the city checking on their whores or picking them up when the Eldorado is in the shop. Then they'll slice open your esophagus for the fare. In fact, WHEN SIGHTED, RUN THEM DOWN.

Tres: DO NOT PICK UP ANYONE OVER THE AGE OF TWELVE IN SNEAK-ERS. They can't afford shoes of leather and nails and will beat you for the fare by doing a track star sprint.

Cuatro: DO NOT PICK UP A FELLOW WITH A KNIFE IN HIS TEETH OR A NEEDLE HANGING FROM HIS ARM. Laugh, but once I was on York Avenue in the Eighties, late, and here was a guy, seventeen to twenty, sneakers, heading uptown,

hailing me with a car antenna he'd just torn off a Volkswagen. I gave him a nice wave as I went past. He looked really pissed. The same expression a banker gives you when you're heading home, off-duty sign on, and you pass him. You know, rage. Will relate it to the wife at dinner. Write a letter to the *Times* about the deplorable state of the cab industry. "Now in London, for example. . . ." Right? Anyway, this cat is *whipping* that antenna around, snapping his wrists like Darryl Strawberry going for the cheap seats, good enough to cut you in half at the waist. I'm up the avenue two lights, checking it out in my mirror when around the corner cruises a Dodge. His roof light is on. Working. Stops and picks up the man with the rapier. Makes a left and is gone. I nearly cried. No kidding. I nearly cried.

Now I'm armed with a knife, a ten-inch Puerto Rican broadsword, which I keep in my bag, and when I get a fare I don't like the look or sound of, it goes under my left thigh, open.

Your changer is a nice weapon, loaded with about five dollars in quarters, twenty dimes, thirty nickels. Slip your fingers through and you've got steel knuckles.

The best robbery story I heard was from Blackie, an old driver, real name is Lefkowitz or Kukowitz, or something, been doing it for thirty years. I missed him shaping up one whole week. Finally he comes in with a bandage on his head. We gather around.

"What happened, Black?"

"I got mugged by a pregnant woman." You had to laugh. I mean a pregnant woman? One guy says, "Kids are expensive these days."

That was good for another laugh. It seems that mama beat on Blackie with a sawed-down broom handle while he was helping her out of the cab. Stole his wallet, his changer, the keys to the cab, and left him for dead among the carrion birds of East Tremont Avenue.

Good to remember it, even for a laugh.

What time is it?

How much of the rush hour is left?

Kick this raggedy cab in gear and go.

ON THE STREET

I came out at four-thirty.

I pick up a guy at 54th and Eleventh Avenue right outside the Cadillac showroom. He wants the Colgate-Palmolive building at 50th and Park. I sling the clock and we're gone down Eleventh, I catch the yellow light at 50th, whip it through and floor it up the block.

The city has been strange the last few days. I mean the weather is mid-May New York. More summer than anything else, but still gray and glary and breezy in the afternoons with the evenings nice and nights warm and clear. And the streets have been mad with sirens lately, ambulances, cop cars, and the big fire trucks with their giant siren and death horn.

I was caught in a jam outside Bloomingdale's around five the other evening, like—nothing's moving and someone is laying on his little horn right on my tail—Beep-Beep Beep Beep—the Voice of the Bug—when this king of a fire truck roars out of 59th Street and tears down Lex, two guys in the raincoats and the funny hats hanging on the back with one hand, boots crossed, you know, really nonchalanting it for the crowd and I'm about ten yards behind them all the way down Lex, running lights with them, doing fifty past the Waldorf, chasing all that red noise. Besides beating a jam, it's a major ball to crank it up and sail down an avenue behind one of those guys. When we got to 42nd Street the truck went west, I missed the light and the guy in the back is screaming about how we almost bought it a couple of times. Don't you know you're supposed to stay 200 feet behind them? the fool asks, paying me and laying a ten-cent tip on me. Is that right? I say, and give him back his ten cents.

When we get to the Colgate-Palmolive building there's an old man lying dead on the southwest corner of Park. We get there just in time to see a scooter cop put his jacket over the old man's face, the crowd walking slow and staring.

$3.40 and he gives me 50 cents.

From five to about seven is the most beautiful part of the day in New York. Everything starts to get loose with people pouring out of buildings and taking that first easy after-work breath. Most of them are heading for home where the other routine begins, or going to get robbed in bars for free cheese and crackers and discount "happy hour" drinks, but out on the street it's beautiful and fluid and sharp. Ever see a little kid staring out a car window in the middle of the evening rush?

I made good quick money for the next hour and a half in the rush up and down

Park, Madison, Fifth and Sixth. A couple of nice Penn Station runs with fares back to Grand Central and the Plaza. Really cooking, in and out. Picked up a guy outside the C.B.S. building on Sixth Avenue and rattled him down to Port Authority—a musician who had the worst day of his life, he said, and was going home to Jersey to get loaded and kill himself.

$2.50 and I get 75 cents.

When he gets out I pick up two well-dressed middle-aged drunks going to some kind of reunion on 14th Street between Sixth and Seventh. They're both Irish and when they see my name next to my mug-shot picture on my hack license we're all brothers. They offer me a drink from a fifth of brown-bagged Ambassador scotch but I refuse. We're really moving down Ninth Avenue, the two guys're enjoying the ride, when we pass three rabbinical students or whatever they are, you know, the young guys in the black hats, beards, sideburns? One guy in the back says, "Jesuits, right?" We all laugh. When we roll up to the address the one guy says he's been in and out of New York City for thirty years and this is the best goddamned taxi ride he's ever had.

$2.60 and they drop a buck on me.

I buy a pack of butts on 14th and Sixth and when I come out two old ladies are waiting for me in the back of the cab. They're all dressed up in their best faded flower dresses and patent leather pocketbooks and they want 116th and Broadway, Columbia University for a graduation and they're very late. I turn up Sixth, left on 15th Street, haul ass through the yellow at Seventh, catch another yellow at Eighth and make a fast, feinting, ducking, horn-blowing run up the avenue without hitting a red light until 57th Street. I mean I was hustling and the old girls loved every second of it, gasping, giggling, their whole lives flashing in front of them.

It was a sweet fast ride up Broadway, me and another Checker leading the pack. When we get to Columbia the streets are mobbed with people all dressed up taking pictures of graduates in the robes and flat hats and at least half the crowd looking for cabs.

$5.70 and they give me six.

The old ladies thank me and take a long time huffing and puffing to get out of the back seat. I finally go around and help drag them out and one of the old gals pats my hand and lays another quarter on me.

Man and wife team almost knock me down to get in, fighting off an old man with a beard for my chariot. Park Lane Hotel, please, and I'm bombing down Broadway to 96th, head east and charge into the park and positively sail at forty-five under the trees, glide around the lake and out at Seventh Avenue and Central Park South, one quick left and the doorman at the Park Lane is helping them out.

$4.50 and I get five and a quarter.

At 59th and Madison a kid in a private school blazer with crest, white shirt and tie hails me. 90th and Madison. I make the left and we crawl. Con Edison has decided to leave Third Avenue alone this month and destroy Madison. But the boy is a good

kid about twelve or so, uncombed hair, glasses, braces, and he asks me a hundred questions. I flip him out when I light up a butt and offer him one. He thanks me, takes it, and says he'll save it for later.

$3.80 and he gives me a dime.

Apologizes, that's all he has. I give him the dime, tell him not to sweat it, we've all been there before, and tell him not to smoke the whole butt in one sitting. He gives me a funny kid's grin and he's gone.

I roll down 90th to Park thinking about the first butt I smoked. It was in a movie theater, and for a long time after that nicotine and heavily buttered popcorn were the worst poisons in the world. A doorman dressed like a Russian general comes up quickly with a nervous young woman, very slim with black hair cut short and brushed away from her sharp, sexy face, and behind her comes a young, very clean, very handsome, very neat man. The general holds the door open for them. She passes me and her face is intense. She has on a short black dress with long pearls. They settle in the back. "Thank you, George," he says to the general, and then to his wife, "Where is it?"

She says to me, and her voice is the Queen Bitch, "We are going to pick up two people on the southwest corner of Park Avenue and 88th Street and then we are going to City Center. Do you know where that is?"

I say, "55th between Sixth and Seventh."

She says, "City Center is on 55th Street between Sixth and Seventh Avenues."

Right.

I'm waiting for the light when he says, "Did you send it back?"

"I sent the check in yesterday."

The dude goes berserk, I mean there's major league violence in him, "You what? You what? Goddamn it! When are you going to grow up, Leslie?"

She says, low and bored, "Oh really, fuck off, David, will you please?"

The light blinks green and I throw the clock and turn down Park. "How your mother ever managed to talk you into that—the bitch."

"You loved it," she says.

"I didn't love it!" he's screaming. "I didn't love it!"

"Are you trying to tell me we can't afford it? I'm tired of that shit, David."

Completely out of control, "No! No! No! No! We can't afford anything!"

For all they know the Pope is driving the cab, I mean I'm not even there.

"Do you see those two people on the far corner?" she says to me.

"Yeah, I've got them."

"Stop and pick them up."

Oh, is that what I'm supposed to do? I thought you wanted me to jump the curb and run them down.

David is stuttering and foaming. "Will you control yourself?" she says to David, like if he doesn't he's going to be in for something when they get home. I imagine their sex life.

As I'm rolling up to the corner David and Leslie go tomb quiet. Man and woman waving and grinning. She gets in the back and he gets up front with me. "Well," Leslie says, "don't you two look handsome."

We're moving down Park. Leslie and the other woman exchange breathy talk. David says in a deep, buddy voice, "How are you tonight, Bob?"

Bob, sitting next to me, about a foot and a half away, has not said a word to me. He hasn't even looked at me. He looks like Randolph Scott in pressed glen plaid, smelling up the front seat with a mixture of Canoe and the cold sweet scent of gin, a regular swamp is old Bob, and he says in a fading Southern voice, "I'm fine, Dave." He pauses. "Considering that I'm not a devotee of the ballet."

The two women stop talking and laugh like they've been goosed by Bob's wit. David comes in with a stage laugh a beat too late.

The women are now talking about wall paper. "Is that right?" "I hear he's very good." "Well, I find it hard to relate to him." "He *is* pretentious." "He did a, marvelous job with Marian's new place."

Bob and Dave, meanwhile, are complaining to each other about being stuck seeing the ballet tonight. "I saw one years ago," says Dave. "It was modern dance. Godawful. Who wants to pay thirty dollars to see a faggot dance in a blue light?" Then they talk business. Insurance. Personnel. Long distance phone calls. Where they have to be Monday. The Board. They must really enjoy each other.

And Bob is totally crocked. His eyes are gone, there's white spit at the corners of his mouth, his hands are lying dead in his lap.

When I turn off Park into 55th we join a jungle of a traffic jam. We're inching along. I manage to get us to Fifth Avenue after fifteen minutes of tight close work, when Dave says, "Let's get out and walk."

Bob says, "No, I think it'll break." The reason he doesn't want to walk is because he's too hammered to stand.

Finally between Fifth and Sixth they convince Bob to hoof it. They get out, Bob steadies himself and then gets into the vaudeville routine with Dave about who pays the fare. Dave, finally, approaching hysteria, insults Bob, calling him "silly," "a fool," "ridiculous," you know? Bob manfully gives in.

Dave leans his head in the front window and says, "What is it?"

"What's what?"

"The fare."

"You owe me four-sixty."

He gives me a five.

I rap out a quarter, a dime and a nickel from my Paragon changer. He says, with a smile, "That was the bumpiest ride I've ever had. You ought to get the seats stuffed, my friend." And hands me the nickel.

"How about I stuff them with your goddamn head, Dave?" And I throw the nickel at him. He starts to get huffy, but I start to get out of the cab and he walks away,

wanting to run to catch up to Leslie and Bob and the wife but managing only a jerky duck waddle. The hell with him. I take nothing from people like that.

I cross town, thinking that maybe I should have chased him down the sidewalk and kicked him in the rear end, you know, total fantasy, when an old man waving his cane at me from the corner of 56th and Eighth Avenue, right outside the old Horse's Tail Bar, reminds me that I'm working. He sticks his head in the front window. "You wanta go to Queens? Sunnyside? Right over the bridge."

"Let's go."

He gets in and I head down 57th Street. I take everyone everywhere. Beekman Place and the South Bronx. Newark and the East Village. I don't care. I'll even pick up Robert DeNiro.

The old man seems partially loaded but he's friendly and happy and tells me how he just won a hundred and twenty thousand bucks from the Briers ice cream factory where he used to work. Seems half a ton of strawberry fell on his foot. "Now, I just drink whiskey, give money to bookies and laugh at the world."

I turn left between First and Second Avenue and take the upper level of the bridge. Driving the top level is always fun because you're really high up and with quick peeks you get the best view of the East Side of New York you'd ever want, from the Brooklyn Bridge all up along the East River Drive past the United Nations and on up the river. But besides the view the real attraction of the upper level is that it's designed like a grand prix course. I mean you come sailing off the middle of the bridge and run through a banked, high-walled hairpin right turn and then as soon as you congratulate yourself on that maneuver you're shuttling fast into a devil hairpin left that can really make you want to shake your pants out if you make it through alive. I've done it so many times that it's not scary anymore but just easy fun. Once you come out of the left you get the most fantastic smell in the city which is the big factory bakery and the smell of that bread would make you believe in God. The only thing like it is another factory bakery on the Brooklyn Queens Expressway as you approach the Navy Yard and downtown Brooklyn.

So I'm whipping through all that heaven when the old man starts to direct me through the warehouse ghetto of Long Island City. I finally drop him in one of those neighborhoods with trees lining every block, full of kids, and a candy store and honest tavern on every corner.

$7.00 and he gives me eight-forty.

I roll out to Queens Boulevard and head west towards the city along the service road. The day has cleared all its gray and glare away and it's just starting to get soft and dark with the evening clouds high and fluffy in reflected purple and pink.

Outside some Mafia restaurant, you know, with the crummy awning and sandblasted front that could become with no problem a funeral parlor if the place ever goes bust, are a woman and man, hailing me. He's Mr. Sport in his white shoes and red face and pocked nose. She's hard-faced and made up heavily.

"I'm goin' to Lex and 41st and then she's goin' on," he tells me.

Making money driving a cab is really easy. Either you plant yourself in the box fourteen or fifteen hours a day for six days a week or you get lucky. I've spent whole nights driving old ladies with shopping bags from one gray spot in the Bronx to another for a dollar fifty a shot. But not tonight, tonight I've got a sweet run back to the heart of the beast. I'm going to be wealthy tonight.

"Couldn't you just stay with him another hour?" he asks her.

"I stayed all afternoon with him."

"Just don't ask me no more favors," he says. "I just don't wanta hear no more favors out of you. 'Oh, please Johnny, oh, you're my only friend, Johnny, I need help, I need a favor, Johnny.' I just don't wanta hear that happy horseshit no more. Hey, cabbie, take the lower level."

"Right."

"Guy, a nice guy, needs a little fun. And who told you you were the fucking Virgin Mary, huh? Who?"

"I was with him all afternoon, Johnny, he had his fun, I just—"

"Ahh," he says. "get away from me. I don't wanta hear it. He gives you money. He gives you a meal. You never ate so good in your whole stupid life. You start eatin' fancy food and drinkin' good wine and you're Jackie fucking Kennedy all of a sudden."

"I just wanted to leave. I felt sick."

"So you take an aspirin. What do you want from me? Sick? I'll tell you who's sick. I'm sick of lookin' at your lousy face."

They sit, silent, and I get off the bridge, swing through 60th Street and really fly down Lexington. The traffic's thinned and it's nothing but cabs rolling downtown.

41st and Lex. "You pay this one yourself," he says to her and gets out, slams the door.

"44th and Eighth," she says. So I cross town and drop her on the southeast corner.

$6.50 and she gives me a quarter.

She's out of the cab and walking back towards 43rd Street and I'm waiting for the light when I smell it. I pull across the street and move in behind a Dodge on the Royal Manhattan Hotel cab line, get out and look in the back.

There's vomit all over the back seat and floor. When did she do it? I never heard a thing. I get paper towels and a family-size can of Lysol from a store across the avenue and go to work.

It's all tan-colored, wet, the color of a wet brown paper bag in the street, with almonds and mushrooms and big chunks of half-digested meat. The smell comes up in my throat and I'm on the sidewalk every thirty seconds or so, gagging, my eyes bleary, trying not to heave. The guy in the Dodge, a freak with long hair, a Rolling Stones t-shirt and a doped grin talks to me while I do it. He gets an airport ride and I flood the back of the cab with Lysol, move up to the head of the line and count my money.

Close to fifty and change booked and about ten in tips.

So I sit back, light up a butt with my eyes on the street, and watch my colleagues working Eighth Avenue.

There was all kinds of action on Eighth Avenue. I heard some joker on the radio the other night making a case for a red-light district for the city. As if there isn't one already. I'd like to cruise him up Eighth Avenue from 44th to 56th and then back down Broadway to 42nd and let him count the women playing the streets and the second-floor hotels and the shot glass bars and guys waiting on corners. The red lights are never turned off.

There was a group of women on the northeast corner of 45th right across from me. And there was a parade of cars circling the block, white men, mostly Jersey plates, timing the red lights so they'd have a minute on the corner to stare at the women. And then they'd circle the block again. A merry-go-round of morons. There was an owner-driver in his big boat of a Polara with his off-duty sign on circling with the rest of the creeps.

The revolving doors of the Royal Manhattan rolled and out comes a sweet-looking woman in a stewardess's outfit followed by three people and a little girl. She waves me up and when I'm next to her she opens the front door and sits her beautiful self down next to me. Tall and built and a timid smile coming out of a gentle face. Her little stewardess's hat is cocked to the side and she pulls at her skirt, brushes her beautiful brown knees and says, "Goot even-ing. How are you?"

I'm smiling. "Fine. How are you?"

"Thank you," she says in a sugar strudel of a German accent. Not surprising, though. The Royal Manhattan is always full of Germans. It's funny because they're all middle-class upright folks, you know, Mom and Pop from Frankfurt, I mean I can see them looking at the brochure from "the beautiful Royal Manhattan Hotel located in the heart of the world-famous Broadway theater district," and signing up for the week stay in New York and then arriving at Eighth Avenue and 44th Street. I've seen some of those straight-mouthed, no-nonsense Dutchmen standing under the marquee of the hotel looking across at Hungry Hilda's topless bar, checking out the old guy hustling change at the corner, another guy arguing with himself, four sixteen-year-old black females in blood-red wigs strolling his way and, like, those poor Germans are lost, they're trying to figure out exactly what they'll say when they get home because they *know* something is happening, but they don't know what it is, as Dr. Dylan says, right?

So she says, "I am a tour guide. I haff ziss party of tourists who vould an-joy seeing Hah-lem."

"Yes?"

"Good you ride zem?"

I look past her and see them, they look like a family. "Sure. Whereabouts in Harlem?"

She rattles some German at them and the young blonde guy, a dead ringer for

David McCallum, rattles back to her. "Zey vould an-joy seeing ass much ass you good show zem. Good zey haff a . . . a . . ." She's working her lipstick looking for the word, the smile, quickly, "a broad rate?"

"A what?"

"No meter," and she pats the clock.

"A flat rate? Hey, no, I'm sorry, I'll have to take it on the clock."

She translates to David McCallum.

"How much vould zat be?"

"Between fifteen and twenty dollars."

They agree. "Now," she says, "you vill ride zem on a tour of Hah-lem and zen you vill return zem here to ze hotel?"

Signed and sealed, I tell her, she smiles at me, really proud of herself for a job well done, and gets out. She was all right.

The little girl is about ten and very serious and she gets in the back with a large plain woman and David McCallum, who, up close, doesn't look anything like him, it's just the blonde hair cut in irregular bangs and the long thin face. And up front with me is this ox, I mean a big dude who looks like a tough whiskey-Indian with hard hands and big-league shoulders and a leather face under lots of oiled hair. A hitter, an ape in a checked sport coat looking like pictures of Max Schmeling, the old heavyweight, the big Hun who Joe Louis whipped for God and country and all that, right? But he looks mean like Schmeling, or maybe Dempsey before he got old and nicely soft like all heavyweights do, but at least a hundred times dumber than Dempsey's face ever was. I say "Hello," to the back of the cab and get two smiles and the evil eye from the little girl. I say "How you doing?" to Max and he turns his whole torso to me, checks me out to my boots and nods his head maybe a quarter of an inch, and looks back straight ahead to the street.

I throw the clock and join the current up Eighth. Oh, yeah, I'm going to be rich tonight mining gold in Africa.

The young guy in the back is the talker. "Accuse me," he says. "But ven ve arrife in ze slums of Hah-lem, it iss fine to take photos?"

"Sure," I say, and whip the Checker around Columbus Circle and get the sling shot acceleration up Central Park West. It really is a fine cab. I'm driving it with one hand and that's all I need. Fantastic cars, Checkers. You can turn the damn things around a pole, they handle really nice. Then I'm thinking, photos? Wow, and here's us at the Statue of Liberty, and here's little Greta at the Empire State Building, and oh, yes, here's the one with all of us and the junkie on the corner of Hah-lem, America, that a nice driver took for us, you know?

"How many until ve arrife in ze slums of Hah-lem?"

"We're almost there," I say, moving fast on the west side of the Park. When I get to 110th Street I cut south and then turn into Seventh Avenue and go slowly.

"Harlem," I say.

"Ahh," they say.

Now, Seventh Avenue from 110th to about 135th is not bad and some blocks are really nice. Hell of a lot better than the gray, liberal, heavily neurotic West Side. Where everyone is groovy and they don't have children but adults posing as kids, all brilliant and weird. Drive down West End Avenue and those aren't kids you see, no, look again, they're all midgets.

The houses along Seventh are poor but nice, like the people who live along there. I was wondering if the Germans could understand that. I could've taken them Eighth Avenue but who needs that? The people along that bombed-out run all hate white cab drivers and this white cab driver has felt like voting for George Wallace a couple of times after travelling that boulevard of broken dreams. I mean people getting in and out of the cab, giving you an address and when you don't know where it is and ask for directions they get furious and tell you to go work downtown where you belong. Or four dudes in the long coats and the little hats drinking wine pile into the cab, call me "son," and, "Hey, son, stop on the corner here and let me rap with this brother, and turn off that *damn* clickety-click meter, what you *hungry* or somethin'?" You know, carrying on like that. So, I don't work Harlem too much. Sunday mornings sometimes, hauling all those sweet old cake-face ladies to church and back. They're good tippers, those old dolls, really good tippers, like a dollar over the clock and sometimes more. They know what it's like to work for tips.

It's the educated morons who couldn't pour piss out of a shoe if the directions were on the heel who stiff you. And give you trouble. I never want to be rich. If that's what it does to you. I mean turns you into a jerk in a suit, and you have to do numbers to cab drivers to exercise some aristocratic command, then the hell with it, I say, I mean I'll be poor, hell, I'll spend my life hauling phychos and mean drunks around before I'll get myself tied into the *Wall Street Journal* life of misery that those humps have. You know what I mean?

So I'm cruising up Seventh Avenue, thinking about all this, and me and the Germans are looking at the families out on the stoops, big mother taking a breath, the old man smoking a butt and sipping a brew, the little shy babies as pretty as princes, the young girls walking around eating ice cream cones, you know, watching night coming in, and I'm thinking how when I read the paper and it's full of news of King Depression making his comeback and interest rates are skyrocketing, and money's tight, and the market is down, and it looks like the dollar is dying, how good I feel about all that, how a lot of Old Testament vengeance fills up in me because I know the clowns on Park Avenue are going to start to panic and their whole cardboard lives are going to crumble, you know? And it's coming, dad, coming like a tidal wave, coming as sure as Christmas. I mean I'll be able to live because I've been in a depression since I started pushing a hack. I'll be able to make it but I know there's no way in hell Dave and Leslie will ever win a fight on a breadline. When it really hits, I mean when we finally work our way back to 1935, all me and these folks digging the breeze on Seventh Avenue have to watch out for is that we don't get crushed by falling stockbrokers.

I'm rolling up to a light when Blondie starts. "Ve vant to see ze slums of Hah-lem. You promise ze slums of Hah-lem."

I know he's mad because now Max turns to me, slow, and his eyes are pencil flashlights. "This is Harlem," I say.

"No, don't fool us, please. No fooling please. Ve vant to see ze *real* slums of Hah-lem. No fooling!"

And I'm thinking, damn, it's not bad enough, huh? You really want the full erection. "Look," I'm saying, "this is Harlem, this—"

But Max says, "Hah-lem! Now!" And just taps, with one finger, my arm, and I cut down the side street wondering why in hell they didn't hang the guy at Nuremberg when they had the chance.

After touring some pretty fair slum side streets and eye-balling that weird 2001 state office building it's still not bad enough. Blondie is speaking low enraged German and badmouthing me in English every once in a while about how I'm cheating them, the woman and the girl are quiet as death and Max is getting restless. I should've hauled them up to the South Bronx if they really wanted to get it on looking at poor people. Blondie is really pissed now, he's not going to pay, he's going to report me, total outrage. And if Max wasn't there I would've really cursed his Nazi soul out, but I know why Max is there. He's the doberman on the chain, he responds to spoken commands, he can snap my arm like a beer pretzel.

So I head for Eighth Avenue. I'm on a side street and we're really moving into the heart of darkness. The street lights are all shot out and I'm rolling slowly through broken glass.

As we approach Eighth Avenue there's an old wreck of a gypsy cab decomposing where it was parked on the northeast corner. The old buggy has all four doors torn off, the seats ripped out, the side windows are gone, the front window is a cobwebbed shatter, and it's resting on four rusted rims. There looks like there was a fire in what's left of the engine.

This turns Max on. He grunts and points to it. "Ahh!" the three in the back say. I've got a red light and while I'm waiting the Germans are chattering away, happy as Hitler in Paris. I'm looking at the crowd on the corner outside "Tyrone's Temple," a storefront whiskey and wine joint with a red light in the window. There are some young men in sharkskin green shirts open to the navel, droopy pants and sneakers and big combs stuck in wooly 'fros. Couple of bush league pimps in platforms and white fedoras sharing a pint of booze and a few thoroughly spaced wine drinkers including a woman bum.

Max opens the door and Blondie opens his, saying, "One minute, please. A few photos," and waves his camera at me.

"No, don't get out, don't—" but they're out of the cab. The woman and the girl are still sitting. I give them a quick look and the woman smiles at me. I pull up in front of the dead gypsy and park. Okay now. Be cool, be tight, just get them back in the cab.

I get out and walk around to the curb which is full of garbage. Max and Blondie are having a ball digging the dead cab, looking inside, talking excitedly to each other. And the people on the corner wouldn't have noticed us at all except Blondie shoots a flash at Max posing in front of the wreck like he just brought it down with an elephant gun.

The bush league pimps start to saunter over and I make my move. Blondie's getting a new angle ready and I say, "Look, there's going to be trouble, get back in the cab."

"Vatt trouble? Vith photos?"

"Yeah, with photos, so let's get back in the cab, huh?"

The first fedora has a bland face and muttonchops and a tiger's smile. "Who you?" he grins. "You reporters?"

Blondie says, "Accuse me. May I please shoot ze photos vith you?" Aims his camera at him.

"Hey, who the fuck are you?"

I say, "Look, man, they—"

"Who you callin' 'man,' chump? Who, just who the fuck are you?"

"I'm a cab driver."

The other one says, "Oh, he a cab driver," and this is very funny.

The first guy looks at the other one and says, "He say he a what?"

"Cab driver," and they laugh.

Blondie's flash whitens the dead street.

"What the *fuck* this man doin'?"

"They're tourists," I'm saying, already realizing that it's hopeless. "From Germany. They don't know what they're doing."

"For *damn* sure. What they tourin'?"

The other one says in his best sweet hustler's voice, "Hey, bro', let me see your camera?"

And Blondie, smiling, hands it to him.

"Look," I say, and notice the sharkskin beginning to gather around, "they don't want any trouble."

"Trouble? Trouble? You come up here, you not lookin' for trouble? What the fuck you aksept to find? What you want? Women? Or what?"

"No, we just want to get out of here," I try a smile and notice the camera has vanished.

The woman bum is in the middle of it now. Her hair is matted and knotted, her face is drunk and pained. She's wearing a short dress and broken down slippers. She's staggering and finally grabs Blondie's arm.

I mean she's filthy, with grime and dust all over her face, neck, arms and legs. There's a damp grimy spot on her dress where she pissed on herself. She must've slept in the park. Blondie's trying to dislodge the woman's grip with his fingers, not looking at her. "C'mon," she says, "c'mon, honey," she's trying to pull him along

with her. "C'mon with me, baby," then raises her voice and she's shouting now, her eyes closed, her hands locked on Blondie's arm, "you come with me, you come with me, just a goddam—you come on, I'm a good lay, you come on," and the men are all slapping palms and doing short, bobbing steps, laughing, when all of a sudden Max is there. His face is all business when he grabs her and shoves her. She's falling to the sidewalk with her dress around her waist, a high-pitched grunt comes from her, she rolls around trying to stand up and everyone is shouting.

Max clubs the pimp in the ear with a bomb of a right hand I never saw coming and the white fedora is flying. When he's down Max kicks him hard in the small of the back. The woman is on her hands and knees, her head bowed and her coarse hair touching the pavement, trying to work her legs to stand while Blondie sprints to the cab. I'm trying to pull Max away but he's demolishing some young guy who tried to kick him in the balls. Max doesn't even know I'm there, he breaks away from me and moves into the crowd, big and so fast, scary fast, moving on the dark street.

The woman is up now. She lunges and Max grabs the front of her dress, pulls her towards him and cracks her full in the face. She's a house coming down, meets the pavement hard and doesn't move and then a red and yellow light and siren is screaming towards us and people are running and it's only me and Max rubbing his hands when a slim Italian cop with a razor cut jumps out of the squad car and levels a pistol at my chest. "Okay," he says. "Move and I'll blow your silly ass away."

The other cop, an Irishman with a beer gut, checks the pimp who's moaning on the sidewalk and then turns to the woman bum who looks dead to me. "What the hell's going on?" says the young Italian. He's got Max and me gripping the wall with our legs spread.

After checking papers on Max in the back of the squad car he motions him to the cab and the Irishman says, "What the hell's the matter with you?"

"I didn't tell them to get out of the cab," and I know I sound crazy because I feel crazy, high-adrenaline crazy, blood crazy.

"You brought 'em up here didn't you?"

"Look, I'm just trying to make a living."

And we talk. They lecture me. They're not bad guys, really. I know cops, I know the whole cop life. The thing about how cops don't have any friends except other cops. What the job does to their lives. How they get hooked on the street.

But these two guys are all right. Better than most. They tell me I'm lucky and I agree and then they give me an escort to 110th and Central Park West. Max is just sitting there. All in a day's work. Blondie, after being soothed and comforted by the woman, starts in on me about who pays for his camera and I explode, cursing him, cursing his nationality, his sex life, his very soul, cursing him in a way I have never heard anyone cursed. I go quiet, finally. I look at Max, he smiles at me. We're combat brothers and his face tells me that he's wanted to curse Blondie for years. But it doesn't make me feel any better.

The clock reads $19.10 when we get back to the Royal Manhattan and Blondie pays me $19.10 with a sneer. I don't care about being stiffed. I don't care about anything. I feel that wasted, cotton-mouthed, hungover feeling. I just drive away, not knowing where I'm going. And caring less.

At 57th and Madison I pick up a young woman and she wants to go to 84th and Second. A digital clock on a building winks at me—10:17.

$4.20 and she gives me five.

I made money up and down the East Side taking *New York Magazine* subscribers from one cute-named bar to the next. Two hours of hauling rich hippies around. I worked solidly, without a break, making money, and no one talked to me because I was playing heavy-macho-workingclass-surly to all their laid-back-big-city-nighttime-sophistication.

Then around midnight two idiots in sport coats and turtlenecks get in at 72nd and York and ask me to take them somewhere to get laid. I was considering driving them to Brooklyn's jungle and leaving them there but I finally said okay and headed for Times Square.

I tell myself this is the last time. There is nothing slimier in this world than a pimp. And most people are fascinated by them and even envious, you know? Which says a lot about most people. So when I'm called on to pimp, and there's no getting around it, that's what it is, I feel like someone just shoveled a load of something that smells bad in my lap. But I've done it, and I did it, but like I said, never again.

At 48th and Broadway they saw what they wanted and paid me.

$3.70 and I get seventy-five cents.

I turn down 47th Street and am ready to rack up the night and try to forget what a pack of garbage my life is when a guy rounds the corner at Eighth Avenue very slowly and surely and glides over and sits in the back. Tall, skinny, dressed all in black, long hair and heavy shades. "How ya doin', man?" he says.

"So-so."

"Hey," his voice is low and easy, "I'd like to go to Pleasant Avenue between 118th and 119th and then, if you wait, back down to 72nd off Central Park West, okay?"

"Sure."

"I'm gonna pick up the wife and then we'll go back to 72nd."

I catch the light in front of the Museum of Natural History. While we're waiting he says, "Hey, man, you smoke dope?"

"Every time I get the chance."

"Cool," he says, lighting up, and I can smell the earth aroma. He passes the J. to me. It's rolled thick and tight in yellow paper and he says in that toke-choke voice, 'It's pretty good smoke, man." I'm sucking it down deep when the light changes. I'm cruising away. When I hand it back I already feel it. Down low in the crotch. "Shit man," he's laughing. "I ain't never seen a cab driver turn it down yet. Even the old guys." So we're smoking. He says, "You know, when I got in I thought you

might be a guy who doesn't party, but I thought what the hell, I figured, I smoke when I want to smoke and if you didn't like it then that's like, uh, that's like, uh, life. You know, man? That's life, right? You havin' a bad night or something?" So we pass the J. and I'm telling him the tale of Max, Blondie, and the family in Hah-lem and he's really digging it, laughing and sympathizing and questioning and being very brotherly when it starts to rain mistily, the streets are turning to ink, the wipers are doing a good job and I'm telling the story up Central Park West when I remember to slow down because an old hump-backed cabbie told me in a diner that when it first starts to rain is the most dangerous time, you know, just when the streets get a little water on them all the oil from the pavement rises to the top and if you begin to even *think* about hitting the brakes you'll go into a skid and then it's "Katie bar the gate" as the old hump-back said and so I'm telling the guy all this and still sucking smoke way way down into my underwear when I stop and say, "Wow. What the hell is this stuff?"

He's laughing in a high, really funny laugh. "Oh, man, I had like two ounces of this stuff a month ago. Was it? Yeah, a month ago and like the guy who laid it on me says to me, 'Go easy on it, man. It's very bad weed,' you know? Like I don't—I mean I've heard that shit a million times, you know? And most of the time, like I smoke two pounds of some shit in an hour and a half and all I get is a monstro headache. But this shit, this shit is positively, without a doubt, wacky weed. Colombian, dig, and it's like, uh, like red pot, and all crumbly and as soon as I saw that I *knew* it was good and hey, man, this is 96th," and I do an A.J. Foyt power skid and we're cutting through the park.

"Got any music?"
"No, I've got nothing in this cab but me."
"You feel all right?"
"Oh, yeah."
"Drive okay?"
"Sure. I'm okay. Sensational grass, man."
"Dig it," he says. "It grows on you."
Everything is cinematic, now, and it is growing. Mellowing and sweet.
"I pushed a hack for awhile," he says and passes me the J. It's endless. I thought we finished it hours ago as I roll across Fifth and take a quick peek down the avenue. It's beautiful in the rain. A string of wet blurred red lights as far as I can see.
"No shit?"
"Yeah. I don't have the head for this job."
"It's a rotten way to make a buck."
"Keeps you free, though, huh?"
"That's the only thing."
"I got a truck," he says. "My own truck. You want this roach?"
"No thanks, man. I'm completely fucked up here."
"Hey, this is Third."

"I'm glad you're watching. I'd have us in the East River." He's roaring and so am I. Not very funny but I don't think we were laughing at what I said.

Flying up Third Avenue catching lights and flashing past storefronts in the rain. He's telling me about his truck and how he runs bananas from the Bronx to the city all day long. "Bananas?" I'm laughing so hard I'm crying.

"Oh, yeah, baby. I'm the king of bananas. I'm high all day long with those bananas. I drive good when I'm goin' straight ahead but you oughta see me when I'm feelin' beautiful and tryin' to back that sucker into the loading dock. Those dudes on the platform really split when they see me comin'. They give me *lots* of room."

Down 118th Street and he tells me to stop on the corner of First Avenue so he can call his wife and tell her he's coming. I'm waiting on the corner watching him standing in the blessed streetlight rain. A tall, skinny young man, hair black and stringy wet.

He runs back in quick funny steps. "Holy shit, man," he's saying. "Why didn't you tell me it was pourin'?"

I turn on to Pleasant Avenue and he's shouting, "Two ways, baby! Two ways!" And I finally realize he hasn't slipped his moorings and gone deranged on me but is telling me that Pleasant Avenue is a two-way street and I'm on the wrong side.

The grass is totally dominating me and I'm nuts as a bunny and Max and Blondie and the woman who flashed all over the back seat are part of a dim portrait gallery that holds no interest.

I begin to go intellectual on myself as I wait for him to bring his wife down. That's not usually a good thing to do when Colombian red pot is with you. You could intellectualize yourself right through the doors of Payne-Whitney so fast it'd be a month before you could tell the doctors from the patients. But tonight I can do what I want because I'm sitting in my hack—sweet, purring, Checker—stoned beyond belief on the holy sacrament, saved from a bummer of an evening by the greatest man who ever blew his head away with boo.

He comes down with an eighteen-year-old madonna, her face soft wedding cake white as she ducks out of the house and laughs when the rain hits her. "Hello," she sings to me.

"Did you get wet?"

"Oh, it's not too bad."

And the guy comes out with a baby bundle and does his Charlie Chaplin run and he's safe in the cab saying to me, "Meet the family."

So we're off to 72nd Street and he doesn't talk anymore to me except for, "How you feelin', man?"

"Better all the time," I say.

"My wife doesn't believe in it," he says.

She says, "You won't believe in it either if you ever get busted, Ray."

So they talk, and laugh, and whisper, and laugh some more. The baby cries and she soothes the pain. I feel like an archangel, protecting the holy family.

Off Central Park West on 72nd they get out at a small hotel. He comes around and says, "Whatcha got on there, babe?"

"Eight-eighty."

He gives me a ten and two ones but I give him exact change.

"Here's a joint. No, take it. It'll last you a week if you do it right."

"More like a month."

We do the drug-brotherhood handshake and he says, "Have a nice night, now, man."

I pull away and make the left on to Columbus, making plans. I'll get the Night Owl Edition of the *Daily News* and then go down to the Market Diner at 33rd and Ninth and have light and sweet coffee, some cheesecake. Then I'll take the cab back to the barn, hang out and see what's happening with the rest of the crew.

I'm waiting at the light at Columbus and 70th. A dog trots by. A poor dog from a poor neighborhood. Mongrel, always hungry, homeless, rootless gypsy, happy as he'll ever be just to be looking for supper and, if at all possible, a few good times in the rain.

The light goes green and I'm gone down Columbus.

But it wasn't to be. That soft lyrical number about the dog? Wasn't true to begin with and anyway there's nothing soft or lyrical about Columbus Avenue no matter what those bars and boutiques near Lincoln Center try to put past you. It's all a matter of tone, as some would say. My tone at the moment was more or less like a kettle drum just recently pounded. Vibrating on the surface, inside dumb with booming. Ripped, in other words.

My great plan to have cheesecake, newspaper and bed lasts as far as 61st Street, when cruising, catching lights, I reach for a butt, and stick fingers into an empty pack. I really burned through them tonight. Twenty cigarettes since that good run to Columbia with the old ladies. I wheel into a space on the east side of the avenue between 58th and 57th. Shut down the cab and go to the deli. It's stopped raining and the air is heavy. Almost knock over a girl, only a kid, maybe fifteen, coming out as fast as I'm going in, sucking on a Perrier. Remind myself that I'm not of this world and to be careful, take it slow.

But it's not necessary to take precautions. Everyone in the place is wired on one thing or another. A guy in the back near the beer cooler with long sandy hair, arms that had worked lifting something all his life, tattooed, purple tank top and red corduroy jeans, standing, his barbiturate eyes as slow and full of self-love as a lizard. Two of those dark Heinekens he's ogling and he'll be ready to drive your teeth into the back of your throat. Three black kids, pretty twisted by smoke and wine, loading up on potato chips, chemical cakes and pies, talking too loud, full of hey man cock and tough dude jive. A young black woman at the dairy counter, worn out from a day of work looking at the kids with hatred in her eyes.

One beauty, nineteen or twenty, long auburn hair and big liquid eyes, her behind flowering in tight jeans, in front of me at the checkout counter, struggling with a

floppy purse to pay for two tall bottles of Pepsi. The counterman waiting. He catches my eye and winks as we both wait for her to come up with the money. The counterman is shit-faced, as always. He's been doing Shaeffers for six hours, keeping a cold one out of sight all night long. Now he's comfortable, so comfortable he's switched to Colt .45 malt liquor which he doesn't hide but lets it ride next to the cash register.

The beauty's hand comes out of her bag like it's been bitten by a cat, and greenbacks float to the floor. I'm next to her, picking them up, doing the good deed. She grins and lets her eyes flirt a little.

"Thanks," she says, and we're still kneeling on the gummed grime of the deli floor. We're two sets of eyes, bodiless, the old, soft, lyrical idea our only possession. She's iced by Valium. I say something like—I don't know, it's either a question or a command, either, "Do you have the moon and tides inside you?" or, more likely, "Embrace my sadness," and she smiles, and we rise off the floor. She turns away and pays the comfortable one at the cash register.

"A sweet thing with money," he says to her as she glares back. "There you are, honey," he hands her the change. She drops it in her bag and steps quickly out. The counterman and I, sad silly brothers, watch her rear end. "Pack of Camels."

"You know the perfect marriage?"

"Yeah," I say, not sure what he's up to. His breath is a tavern.

"A stacked bitch who owns a liquor store, and me."

Outside she's standing in the street next to my hack, clutching her floppy purse and bag of Pepsi, one arm up for a cab. There's no traffic yet. Way up the avenue there are three cabs waiting for the light outside O'Neal's Balloon. The beauty is trying to catch the eye of a cab unloading passengers at Roosevelt Hospital. I unlock the Checker and call, "Where you going?"

"Downtown," she says. "St. Luke's Place?"

"C'mon," I say, gallant as hell, and she's settling in the back. I'm out into the river of Ninth Avenue and gone again, slinging the clock. Yeah, I can do St. Luke's Place. If she'd said Queens or Brooklyn, Lancelot would've left the maiden to fend for herself.

The Market Diner flows past at 33rd as I break open the deck of Camels.

"Why do you leave it open?"

"What's that?"

"This thing—what do you call it?"

"The partition?"

"Why do you leave it open?"

"It's easier. And with it closed I feel like I'm in a cage. Claustrophobia."

She leans forward to light her Newport off my match, her head poking through. What hair. "Isn't it dangerous?" She leans her arms through and looks ahead.

"Yeah. But what the hell. If they're going to get you, they're going to get you." Lancelot has now become John Wayne. "It's like the man who smoked for thirty years, gave them up one day and the next morning was hit by a Chesterfield truck."

"Oh, the poor guy." She really was young. "Was he hurt?"

"Walked away without a scratch."

"Lucky. You want a hit off this Pepsi?"

I take the bottle and swallow. "What a neat tattoo," she says. "Is that a fish?"

"Yeah," I say, hand her the bottle back through and leave my hand there so she can dig it.

"How'd you get it?"

"A moment of temporary insanity," I say. A rehearsed line, but it usually does the trick. She doesn't ask me about it again.

Past the Old Homestead and into the meat district, rumbling along on dark Hudson Street. You really do get to be like John Wayne after a while on the night line.

Down Bleeker Street towards Seventh, the sidewalks filled with gays and tourists. Up ahead I see two men walking, their backs to me. One is short, slight, shaggy blonde hair. His partner is bullnecked, checked sport coat, linebacker shoulders. Could it be? Why not? It's been such a weird night, why shouldn't I catch Blondie and Max handholding in the Village. Put Mom and Sis to bed and we'll go drink beer out of a bottle and listen to Liza Minnelli in some dark bar. The beauty is chattering away about her brother who had a bad accident once and I'm leaning my head out the window ready to yell at them—something just to get their attention so when they look at me they'll freak—when I catch their faces—it's not them. Close, but not them.

"They friends of yours?"

"No, I thought I knew them."

"Are you gay?"

I check her out in the mirror. She's sitting back, exactly centered on the bench seat playing with her hair. "No."

"I have a gay friend," she says, proudly.

"No shit?"

There was the time I was working in the early evening rush, stopped at a light at 39th and Third when I saw my wife crossing in front of me. She saw me at exactly the same time and came over to the cab, said, "Hello, darlin'," leaned in and kissed me full on the mouth. Then she walked away. A block later the guy in the back says, "Do you know her?"

"Never saw her before in my life."

Another block and he says, "Shit, what am I doing in marketing research?"

I catch a light at Christopher Street and watch the parade. On the west corner I notice that Boomers is gone. Now it's a gay bar. Once it was a jazz bar. Pretty good food and it jumped all night.

Down Seventh and I make that nice easy dip into St. Luke's Place, and enter the 19th century. Gas lamps in glass boxes on black stems, the light wavering on the spring leaves of trees. Brownstones with window boxes and tall windows. See, St. Luke's Place is really Leroy Street until it gets to Seventh, then it changes its name for only one block. After Hudson Street it's ordinary old Leroy Street again.

She gives me a number and before the cab is stopped she's got the door open, saying, "Be right back," and is up the stoop towards a door flanked by cut glass.

I'm waiting, sitting in the shadows of the Checker. Up ahead, at the end of the block, across Hudson, sits the big building where I worked one summer, fall and winter. It's a mail order house, sending out merchandise all over the U.S. Years ago. Jesus, years ago, and here I am, the dope wearing thin now, pushing a hack, late, too late at night. I quit the warehouse on Christmas Eve, walked out along with the hundred or so Pakistanis who had been fired that day. They were all right off the plane, had been hired around the first of November, and canned, without warning, on December 24. I walked, too.

Just a few months ago I had the personnel manager, the guy who hired me, in the cab. He didn't recognize me, but I pinned him from a block away. I was all set to get on his case, but didn't, and drove him in silence to Forest Hills from midtown.

That silence, that wall, is the worst part of hacking. Much worse than a razor blade at your throat, worse than getting shafted by the boss, spun around like a kid's top by injustice, the naked logic of bossism, to fall into the arms of the union, waiting to rob you all over again, screw you, shaft you and then, holding up empty palms to you, the corrupt New York shrug of the shoulders asking, "What did you expect?" Yes, the silence is much worse, the inability to hang yourself out on the line, to take the risk, like the silence the other night, a silence I'll take to the grave.

It went like this: A doorman waiting for me under a canopy, the east fifties, an empty canyon of a street. Man and woman expensively dressed (his sneakers must cost seventy bucks) while the doorman holds the door. Slightly drunk, and their smells are sweet, heavy, rising. Then—a smell of flesh. She fellates him while I drive, silently, to Chelsea. A townhouse on West 24th. He sees her to the door. But doesn't kiss her. Then I drive him to a West 88th Street apartment house in silence.

Anyway, the personnel man, the day he hired me, pointed out the window of the fourth floor of the factory and said. "That's St. Luke's Place. See? It should be Leroy Street, but Mayor Jimmy Walker—did you ever hear of him? He lived there, in one of the brownstones and so he changed his block to St. Luke's Place." That information is the only solid thing I took from the job.

Another cigarette. Why didn't I say anything to him?

She's back in the cab. "Do you know Avenue R in Brooklyn?"

I turn around and look at her. She's got only one bottle of Pepsi now. "Come on," I say, as tough as I can.

"Take the tunnel and—"

"Why didn't you tell me you were goin' to Brooklyn?"

"You have to take me. I know my rights."

There's steel in this girl. "Okay," and I floor it up the block.

"Take the tunnel."

In the yellow world of the Brooklyn Battery Tunnel, a monument to engineering, yeah, running how many feet under the Harbor of New York? where cops—are they

cops?—or just workers in uniform?—patrolling on catwalks, or standing in glass boxes—goddamn, *there's* a job—up ahead of me an Italian in a Trans-Am, his hair like a crash helmet and a doll next to him in a silk blouse and her hair like a geisha, their tape deck even I can hear bouncing off the tiles moaning Chuck Mangione, Jesus. I'm really fading, and the Trans-Am is lane jumping, are you ready for that? Lane jumping in the tunnel, flying through all that dirty yellow tunnel world.

I'm smoking, thinking of Avenue R. Pool shooters, who are any good, think of the *second* shot, not the one they're making. Cab drivers, who are any good, do the same. It's the next job. Say you get a job to the Port Authority at 178th and Broadway. What do you do next? Wait there five minutes if there's no line, then either hit the highway and get down to 96th Street, or cruise Broadway down. I'm thinking, Avenue R? Oh, no, it's two in the morning now, I'm sunk, I'll have to dead head all the way home, the pot's wearing thin. Maybe I'll hit Kennedy and get lucky. Still the joint he gave me. Maybe after I drop her.

"Here's the toll," she says and hands the quarters up to me. I toss them in the basket.

"How come you guys don't ever want to go to Brooklyn?"

"What guys?"

"Cabbies. Why?"

"I love to go to Brooklyn."

It'll be hours before I get home. Hours. Useless thoughts, some would say. It's all illusion, useless illusion, like the rain that's starting to drift down again, like me and the Checker, and the beauty, talking happily now about those wonderful guys, the garrulous, too funny for words, eccentric, endearing cab drivers of little old New York. The Belt Parkway rises up and below is the Borough of Churches. I can see the empty streets down there, one car turning into a block slowly, like a toy, as the Belt takes us higher. Beyond is Manhattan, staring at us. The Goya sign is turning green. And I'm now straight as a cub scout. No longer lost in space. But lost here, right here and now, the present tense, right on the hammer of reality, I'm lost.

I take the left fork, dipping down and away, maybe too fast, it really *is* raining, and although it might be all illusion, Zen masters die in car wrecks, too. I'm as real as this dashboard. There's no one but my Checker on the Prospect Expressway, headed for Church Avenue, the ass-end of Brooklyn. I'm as real as this steering wheel. Real as this headache.

The diner is doing good business at three in the morning. It's one of those places on King's Highway, you know, fake everything, right? Fake wood panels, fake flowers, even all the plastic looks fake. The lights look fake. I'm at the counter, one of those new ones, where you take a seat and find you're almost on the floor, while the waitress towers over you, her thighs level with the counter. It's like a Jerry Lewis movie, the whole place.

And the waitress, oh, the waitress! She's serving me now, her necklace says *Linda*. She sets down two eggs over easy, ham, potatoes, toast and coffee. Blonde flowing hair, flawless skin, long red finger nails, Betty Boop eyes, and creamy long legs in a short black skirt. Full of smiles and second cups.

I'm zipped again, or could you tell? I dropped the Pepsi princess—$14.20, she gave me $15—forget it, she's just a kid anyway, swung out of there looking for home and busted the joint. Sweet home marijuana. Wheeled into *The Log Cabin,* or *The Odyssey,* or *The Plantation,* or whatever they call this place.

Guy sitting next to me at the counter drinking light and sweet coffee and working on a long slow cigar. Southern, by the sound of him, and how lost is this guy, how far is he from the hammer of reality? Thirty-five or so, mod razor cut, flashy shirt and jeans. Burned out, french-fried, dissipated, another sad silly brother of mine, obviously been up two or three days. Puffy, overworked eyes, trying to make time with Linda. Talking constantly about anything to anybody who comes near him, lost in a speed jag, lonely, running a hundred miles an hour. Talks to me about the weather like it's life or death. "Well, hail, boa. Ah took it on up there to Syracuse the other day and would you believe ah hadta keep mah air on all the way?" Then he's shifting gears and telling the lovely Linda some weird story about a can of paint. Only one remotely interested in what he's saying is himself.

I skarf the breakfast and Linda's refilling the cup. Coffee, yes, and some dexedrine to go with it? Hit this cracker here for some ups? No, I don't need that. Hook up with him and I'll be haranguing people on street corners three states away by next week. I've already done too much pot. It takes me, I mean really tackles me.

The working-class hero. Some kind of idiot dope poet. Eating breakfast at three, getting a hard-on from a waitress.

I play some tunes on the diner juke:
Linda Ronstadt's "Tracks of My Tears"
The Bee Gee's "Jive Talkin'"
Bill Withers' "Ain't No Sunshine When She's Gone"
Hank Snow's "The Great Speckled Bird,"
and for the benefit of my speedy brother at the counter, something called "Hank Williams, You Wrote My Life," by God-knows-who. Couldn't agree more with that whiny-voiced anonymous dirt farmer.

Outside in the lot my Checker is gleaming in the light rain. I check the gas gauge (fortunately it's working, never a guarantee with a fleet cab) and see I have enough to reconnoiter JFK.

Around the Belt, doing seventy. I see a tanker, lit up, moving as slowly as a ship in dreams, clearing the Narrows, running under the bridge out to the open sea.

Voyagers.

Wanderers.

Bound for?
Home?
Peace?
Ithaca?
JFK is silent, alone with its architecture, a forest of lights in the rain.
At American there's only one cab, an owner, asleep at the wheel.

END OF SHIFT

IF you return to the garage around midnight there's twenty to thirty cabs lined up to be gassed and then put to bed in the lot. Cashing in can take forty-five minutes and no one hangs out, no one stays to talk, it's still early enough to get home and in bed before two.

After two is another story. Cabs come in at a slow but steady pace, you can gas up and cash in within ten minutes if you've already toted up your trip card. This is done by cooping somewhere, alone, counting the take. A good place is down near the Con Ed plant at 15th Street, or in the forties off Eleventh Avenue. Private places, places where you can get out, stretch your legs, feeling for a moment as unsteady as a sailor on dry land, missing the pitch and roll of a deck. Wherever you coop, it's important to be alone, to allow yourself the first feeling that work is done.

Another favorite spot is any one of the emergency parking areas off the West Side Highway between 125th and 96th. There you have the river to yourself, flowing strongly down to the harbor, the lights of Jersey falling on the water.

In the afternoon the drivers' room is a cauldron of people. At three in the morning it's a haven, a small club, a place to relax, to meet people individually, to take a reward of peace from the uncertainty of the night. Troy has become Ithaca.

Yeah, I had a fare to Ithaca once.

Listen to this. *Ithaca?* Shit, man, that's a day's ride. Don't hand me that.

Monroe in yet?

Who?

Monroe, Menloe, you know him, the little spacey—

Hey, I heard we get new cars next week.

It's about time. Man, the shitbox I had tonight—

I hear they're gonna be Chevies.

Chevies? Come on.

Little Impalas.

What about Checkers?

They stopped makin' Checkers. Don't you read the paper?

Why'd they stop? This is the best cab ever made.

Gone the way of the buffalo, man.

Yeah. The dinosaur.

You hear that? Listen to this. They're changin' the fleet to Chevies.

Assholes.

No, they don't make Checkers anymore.

What'd you book?

So this cat in a tuxedo gets in at Third Street and Second. He wants Jewel Avenue in Queens.

He was one missing person.

You still got that blonde hash?

Sure, how much you want?

Rangers win tonight? My radio went south in the middle of the third.

You workin' tomorrow or what?

I got my kid this weekend.

Shit, look at this. A hundred and ten booked and twelve dollars in tips.

They don't like you, man. You got an attitude.

Anyone seen Monroe?

Did you see that fire on 110th and Broadway? Wild. Absolutely wild.

Like the buffalo.

Yeah. The dinosaur.

You workin' tomorrow?

I got school.

Let's go to the bar.

Where's that beer? Is it cold?

It's free, what more do you want?

Dawn can come, falsely, and linger for an hour before shadows grow out over the lot, and day men drift in, full of sleep, ready to work, to cruise languorously towards rush hour. On the subway home other workers dreamily make their way to day shifts, and the night line driver holds his fatigue as a jewel, a drug, a memory, a release, a comrade.

> . . . the childman weary, the manchild in the womb.
> Womb? Weary?
> He rests. He has travelled.
> With?
> —James Joyce, *Ulysses*

Shaping Up

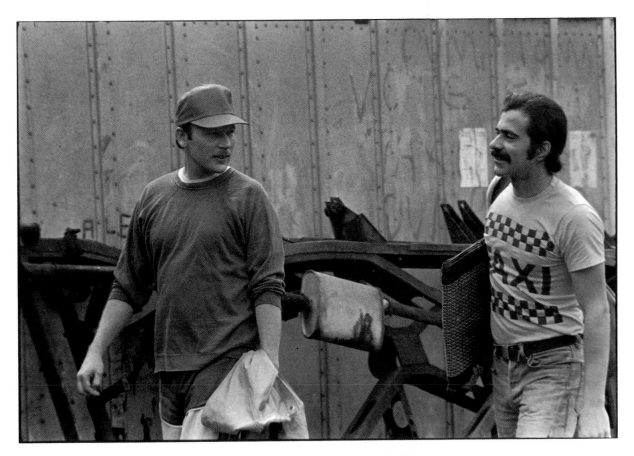

BOB AND DEMO—COMING IN

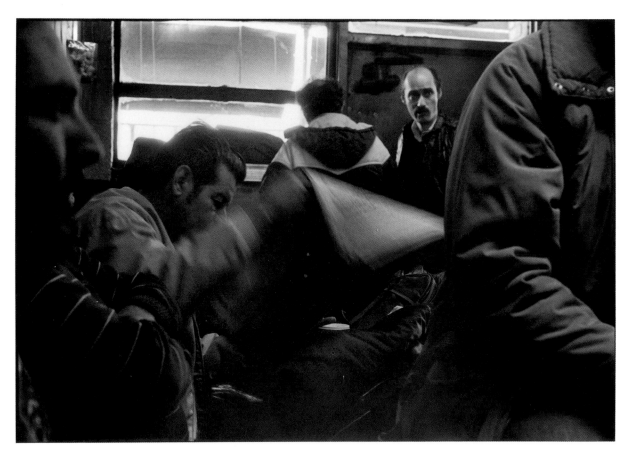

SHAPING UP—IN THE DRIVERS' ROOM

SHAPING UP

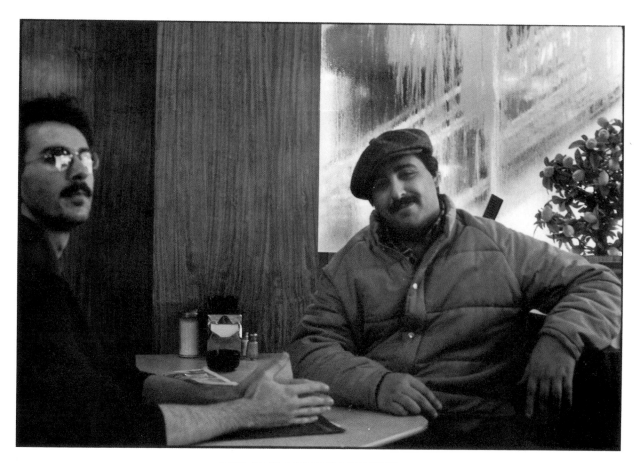

ROY AND MIKE IN BEEBE'S

ROY HOLLAND

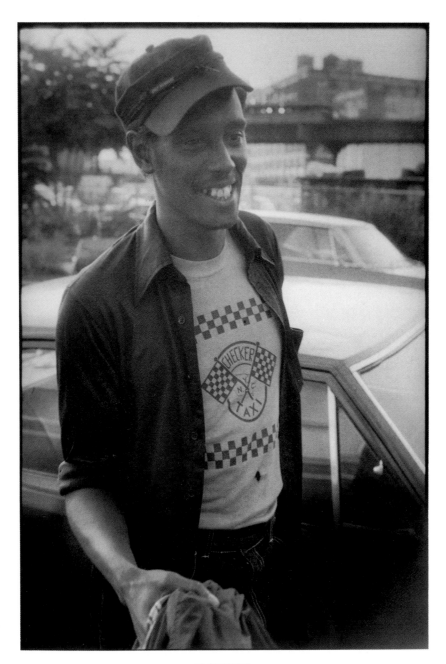

SMOKEY

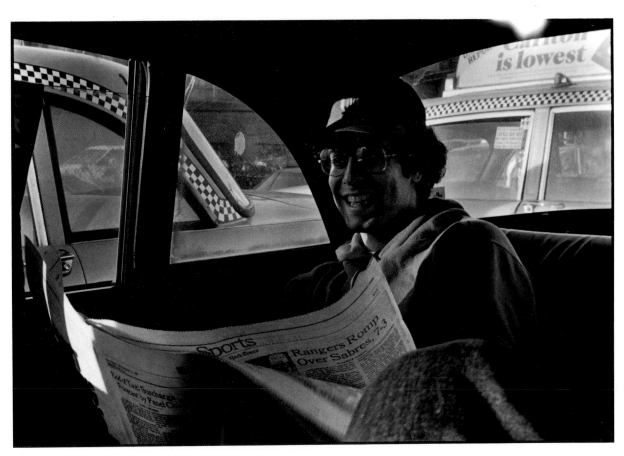

DANNY K.

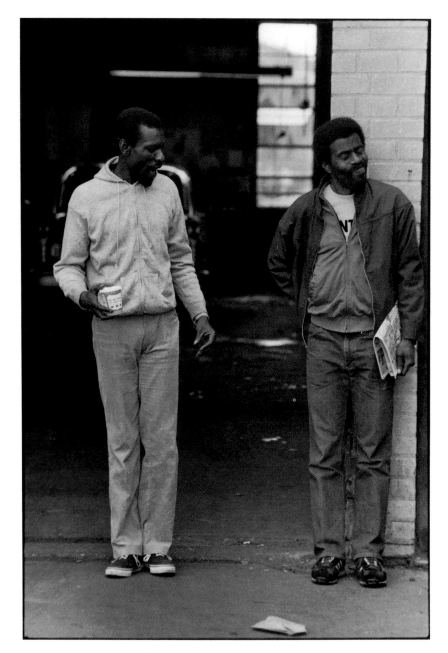

AL AND JOHN—SHAPING UP

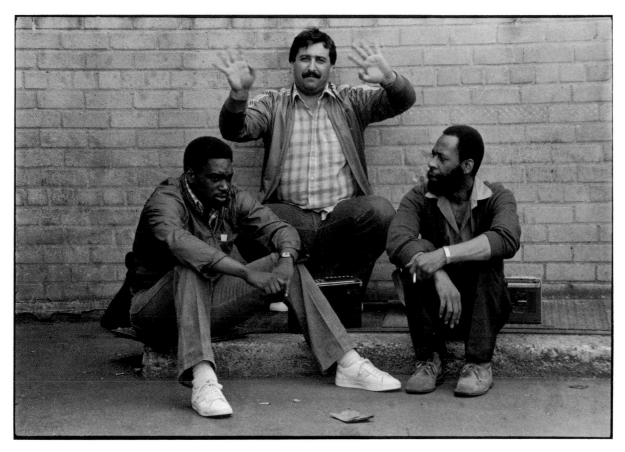

THREE DRIVERS

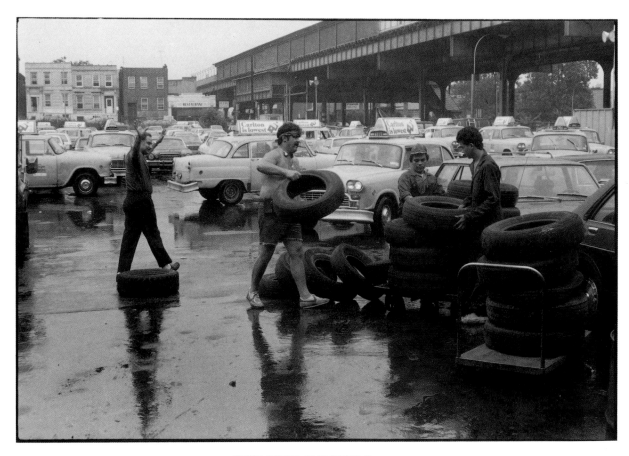

THE TIRE DANCERS

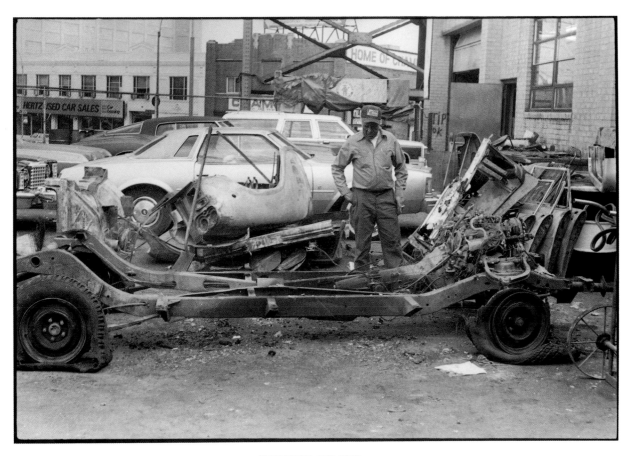

WRECK OF 022

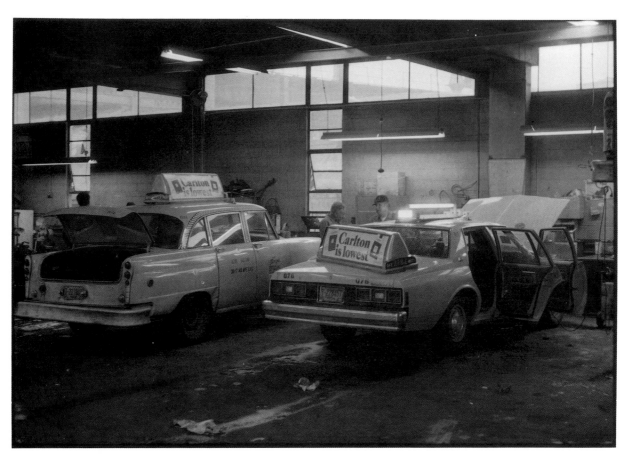

CHANGING THE FLEET

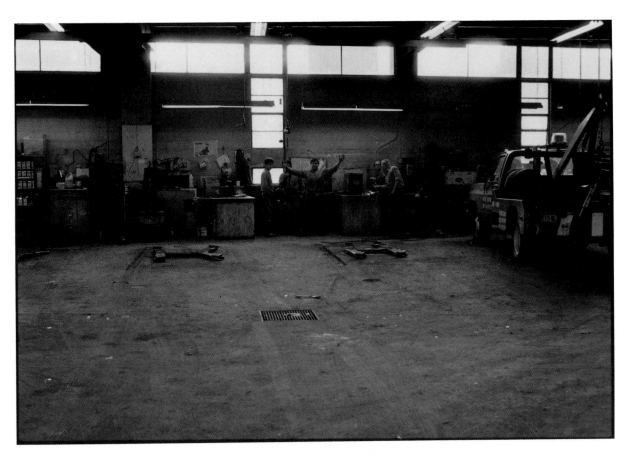

MECHANICS/GARAGE INTERIOR

A CABBIE'S DAUGHTER

MARLENE

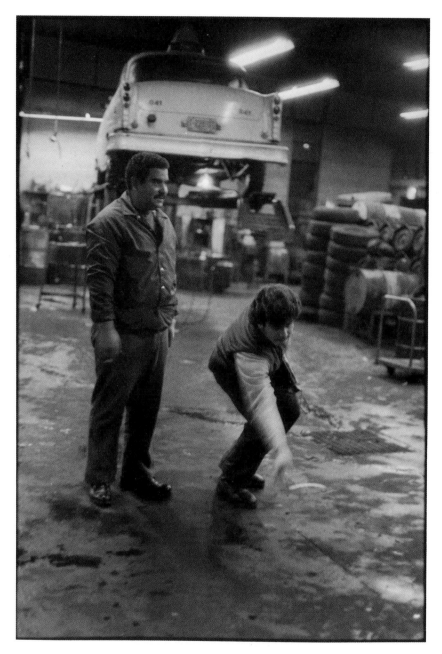

PITCHING QUARTERS

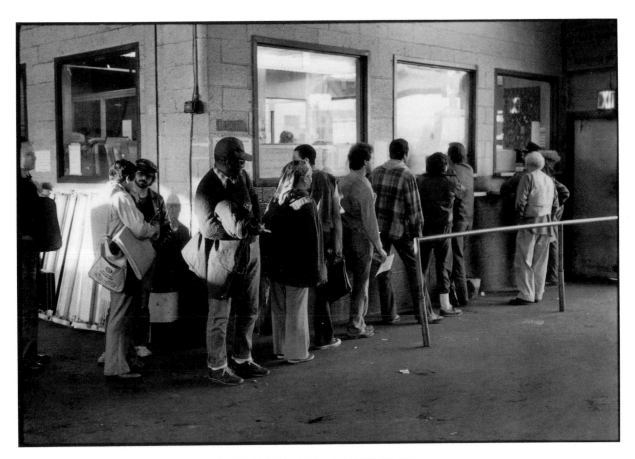

THE DAY LINE—CASHING IN

Change of Shift

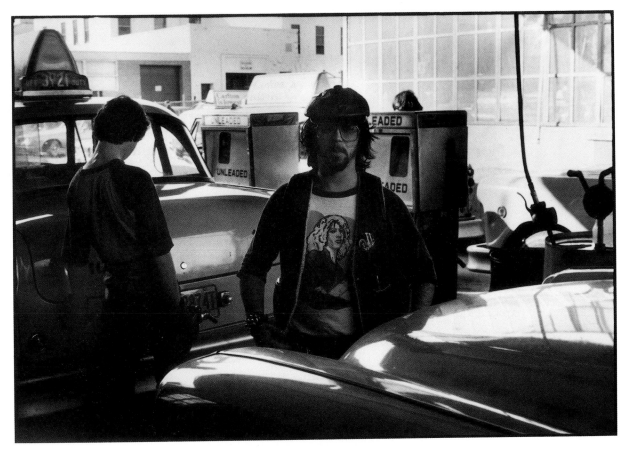

CRAZY JOE—AT THE PUMPS

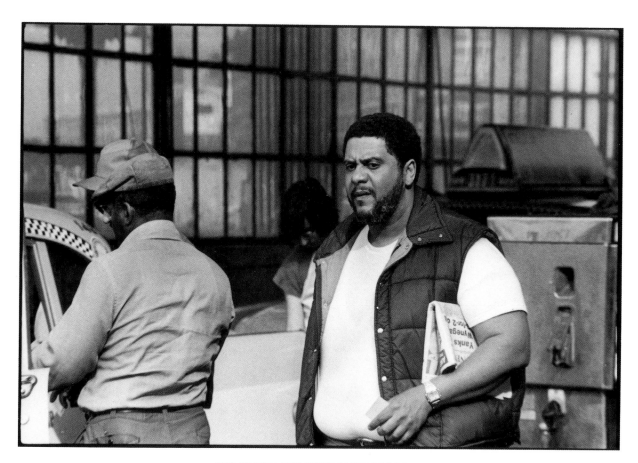

WAITING ON THE DAY MAN

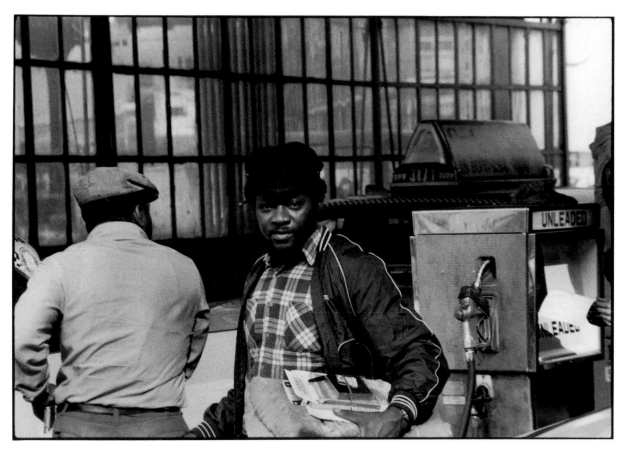

A DAY MAN—COMING IN

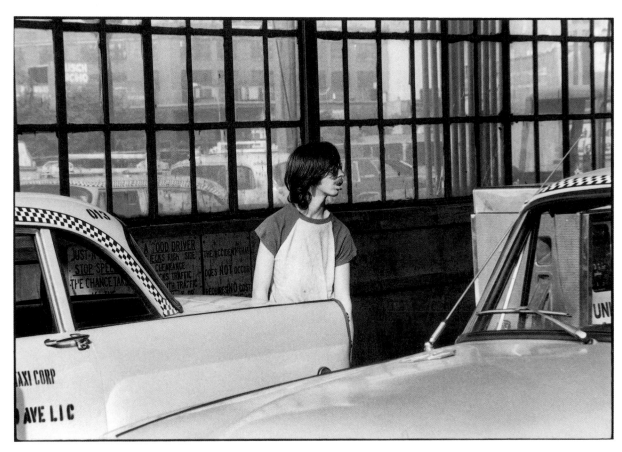

GASSING UP

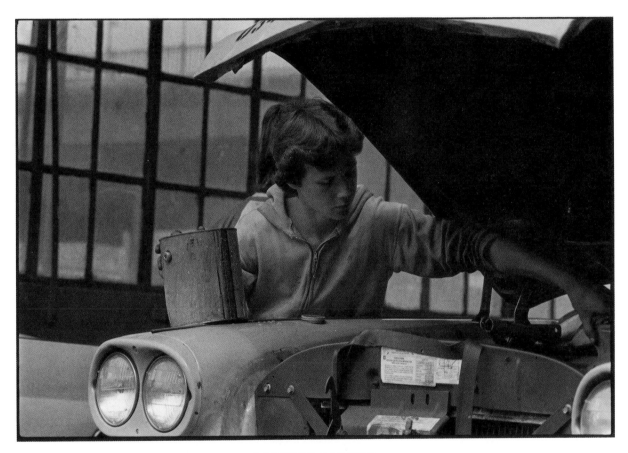

A YOUNG GAS BOY

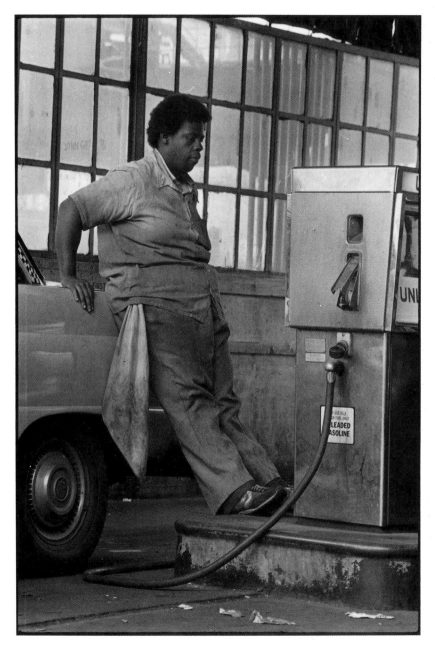

REGGIE

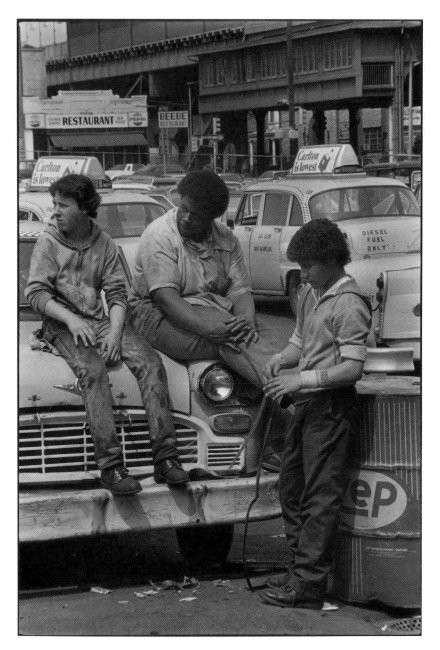

THREE OF THE GAS BOYS

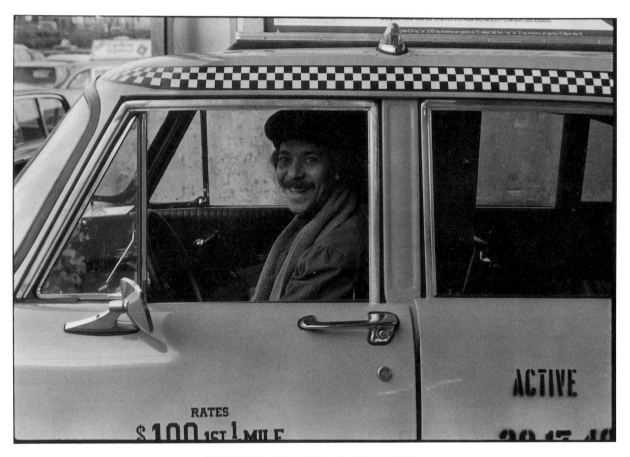

ARTEMIO SUAREZ—GOING OUT

On the Street

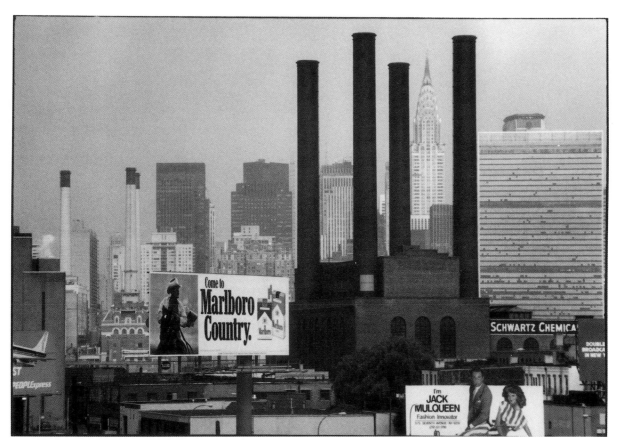

VIEW WEST FROM PULASKI BRIDGE

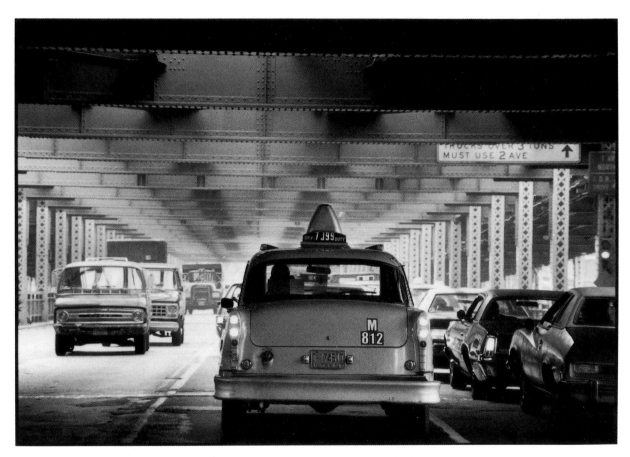

MIDLAND 812—ON 59 ST. BRIDGE

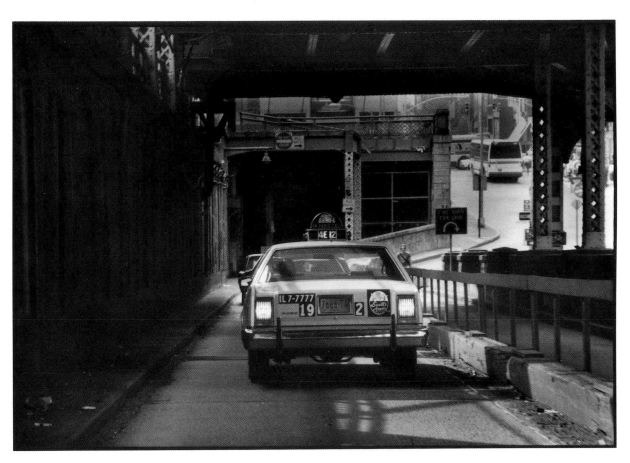

SCULL'S ANGEL—ONTO 60 ST.

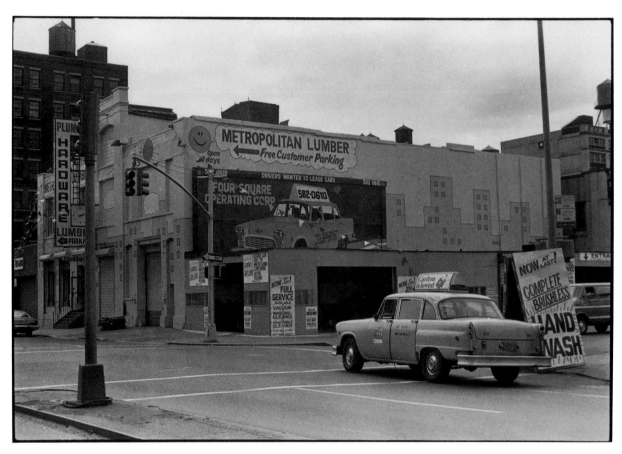

METRO 131 ON 11 AVE.

MR. GRANT

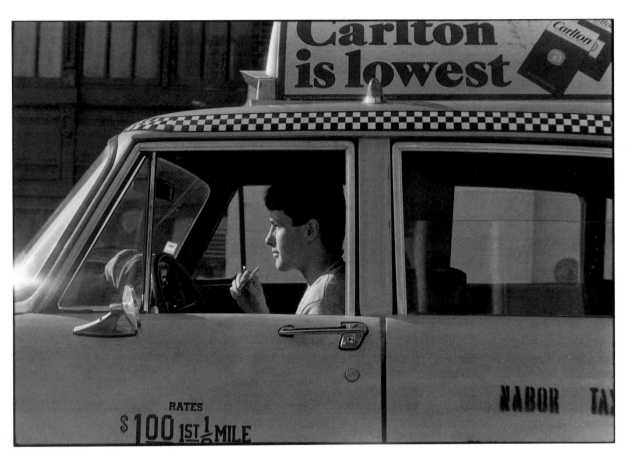

GEORGE BUNGERT

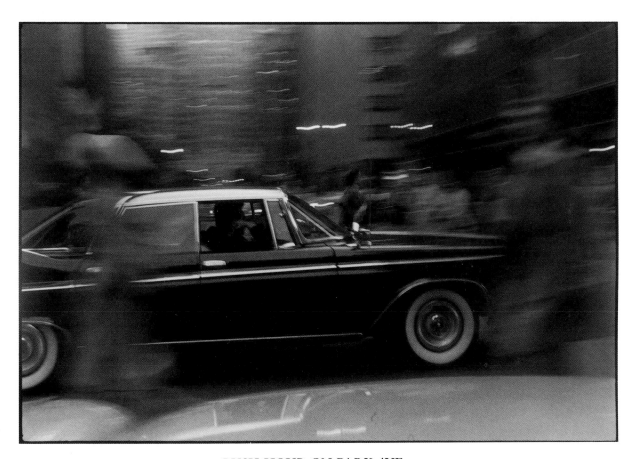

RUSH HOUR ON PARK AVE.

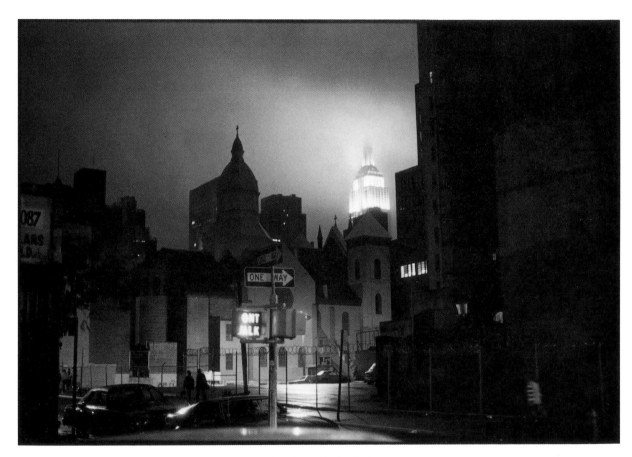

E.S.B. IN CLOUDS

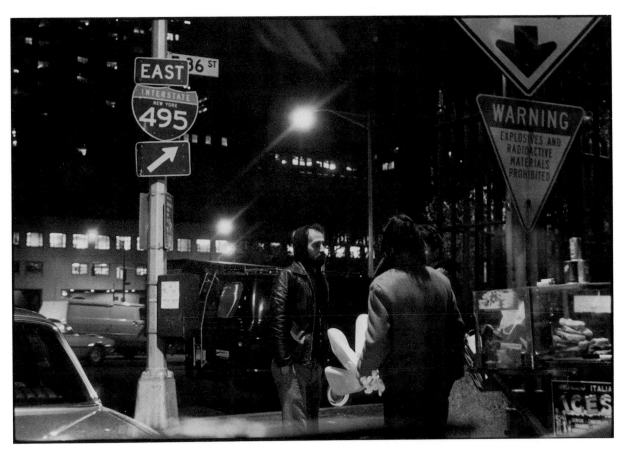

STREET VENDORS—MIDTOWN TUNNEL

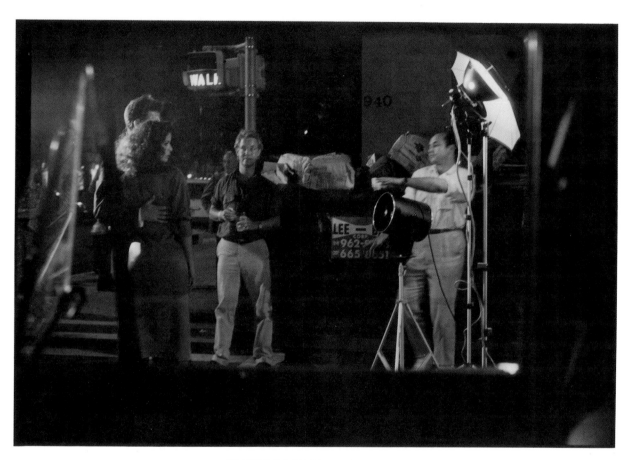

FASHION SHOT—PARK AVE.

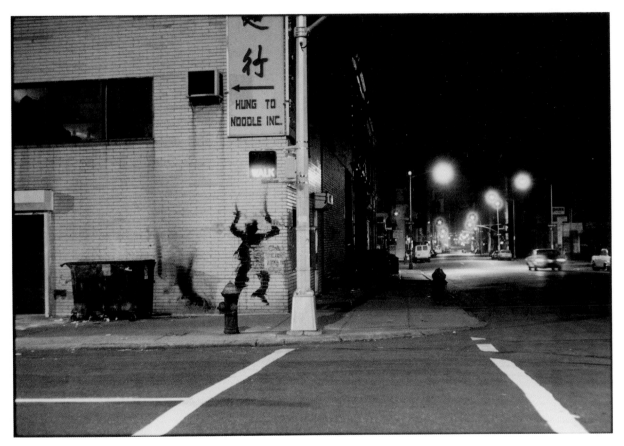

THE GENIE

COPS

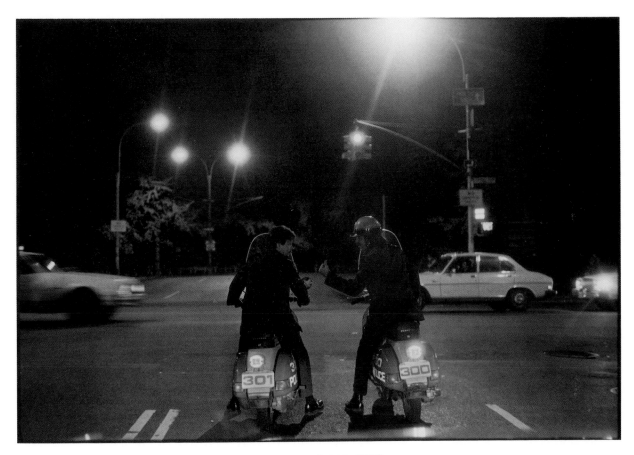

TWO COPS ON CPW

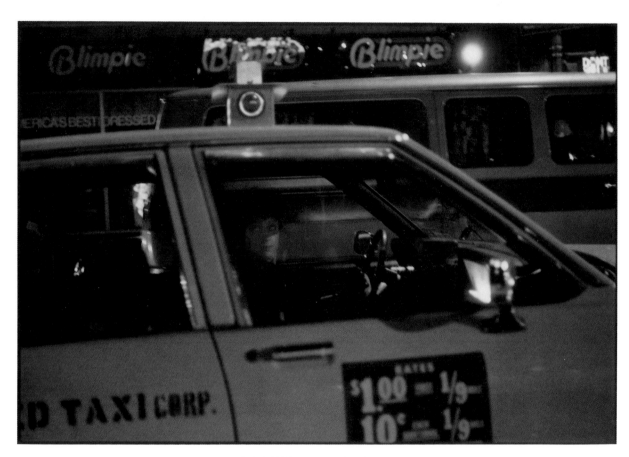

CRUISING FOR A FARE

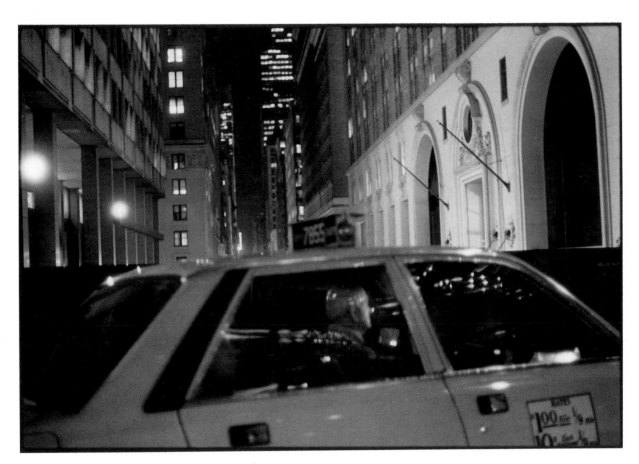

ON THE PARK AVE. OVERPASS

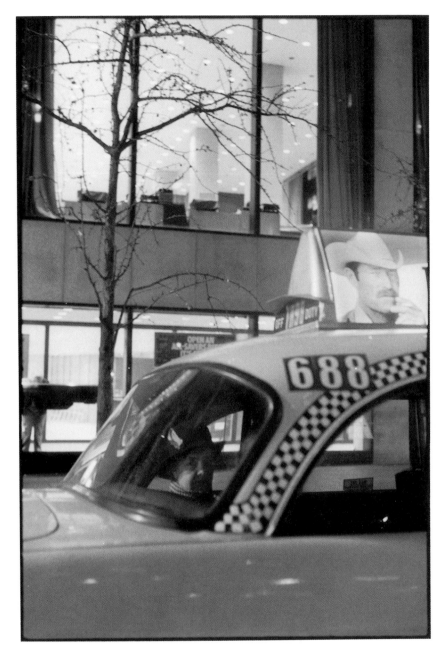

CORONA 688—WORKING

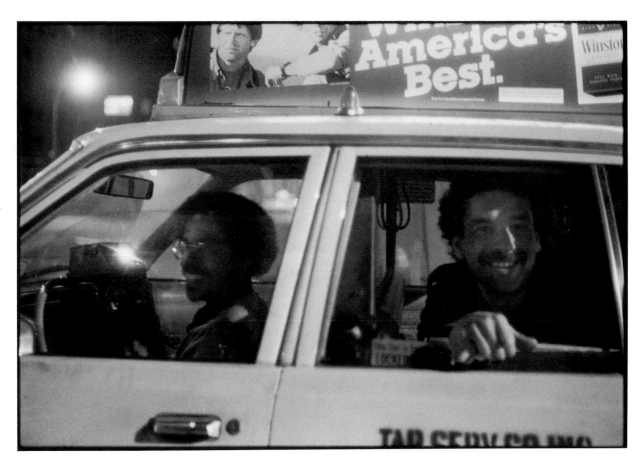

"AMERICA'S BEST."

AGE CYCLES—W. 3 ST.

AT THE ST. REGIS

JUMPING THE LINE—JFK

FOREST OF LIGHTS—JFK

RAIN—2:30 AM JFK

RAINSPOUT—TWA/JFK

TAXI LINE—TWA/JFK

CALVARY CEMETERY/QUEENS BLVD

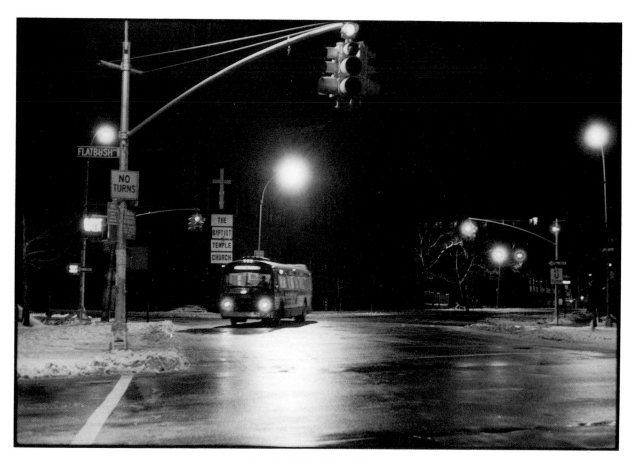

ON FLATBUSH AVE.

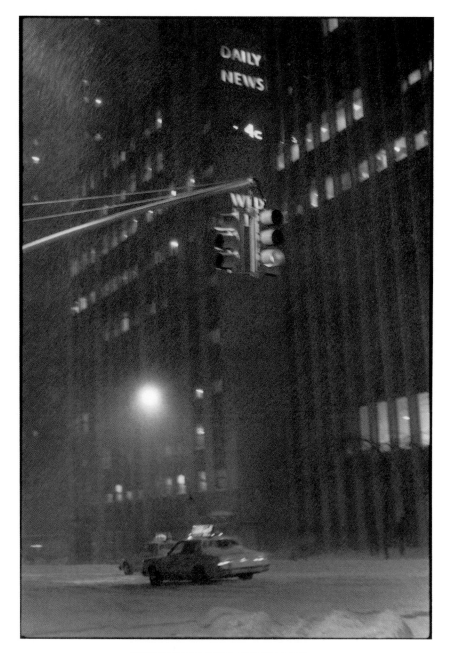

WORKING THE BLIZZARD

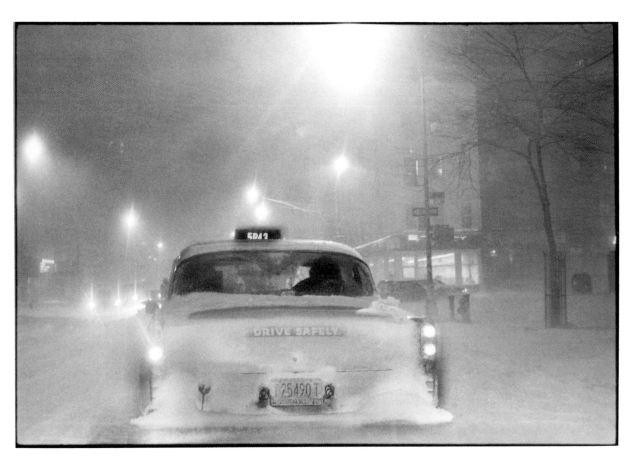

WORKING THE BLIZZARD—34/2

SNOWPLOW ON CPW

WORKING THE BLIZZARD—BROADWAY AND 65 ST.

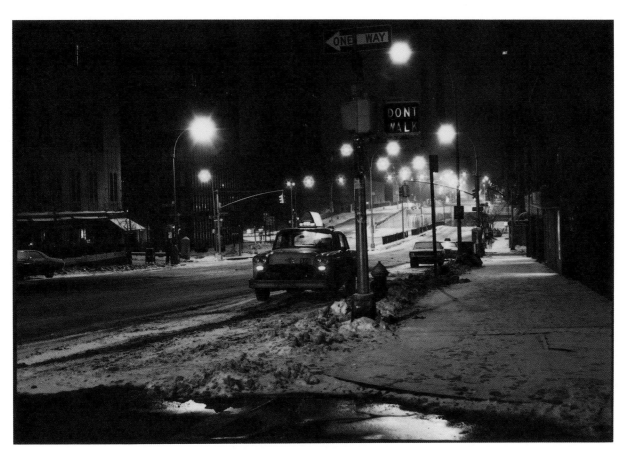

MIDLAND 906 ON 1 AVE.

JONATHAN—DRIVING AND COUNTING

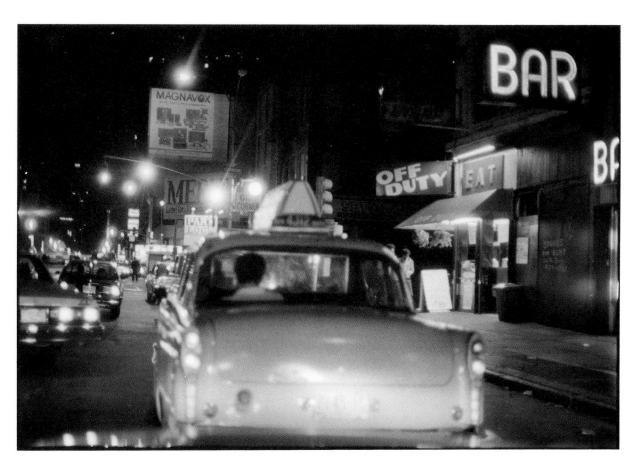

THE OFF DUTY

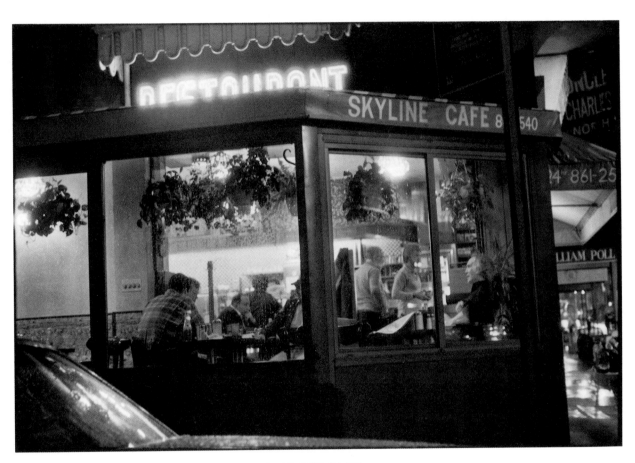

SKYLINE CAFE

LOW CLEARANCE

EAGLE ELECTRIC

CAB ON DIVIDER—PARK AVE.

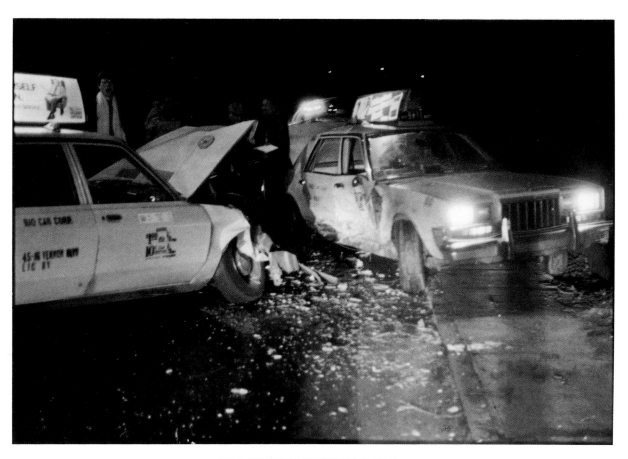

CRASH/TRANSVERSE RD. 1

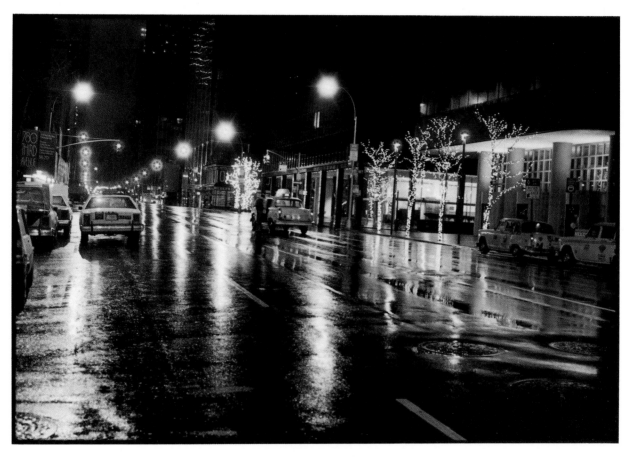

RAIN/3RD AVE.

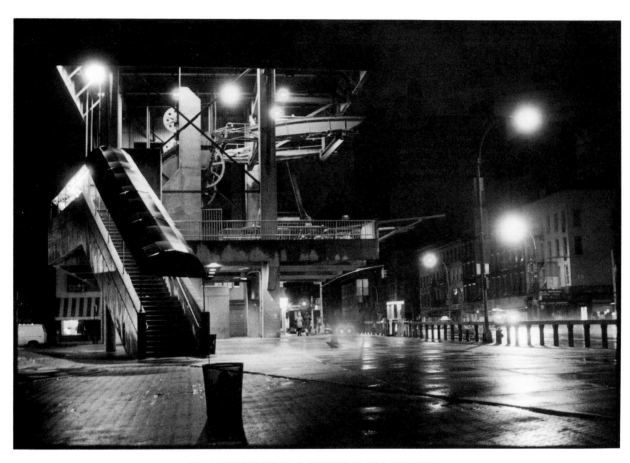

TRAMWAY FROM QUEENS HACKLINE

HACKLINE/1 W.T.C. (#1)

HACKLINE/1 W.T.C. (#2)

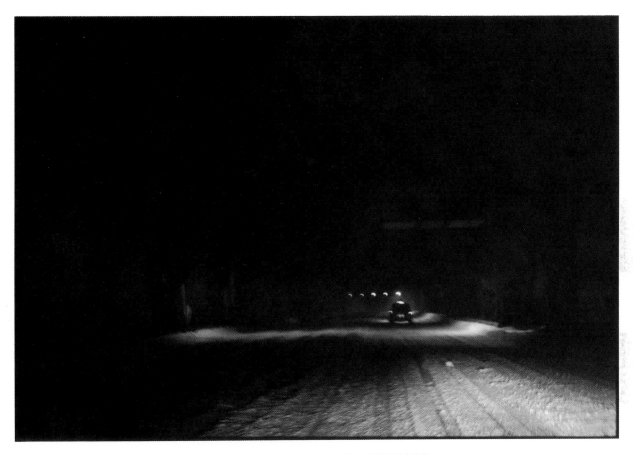

RETURNING FROM THE BLIZZARD

The End of Shift

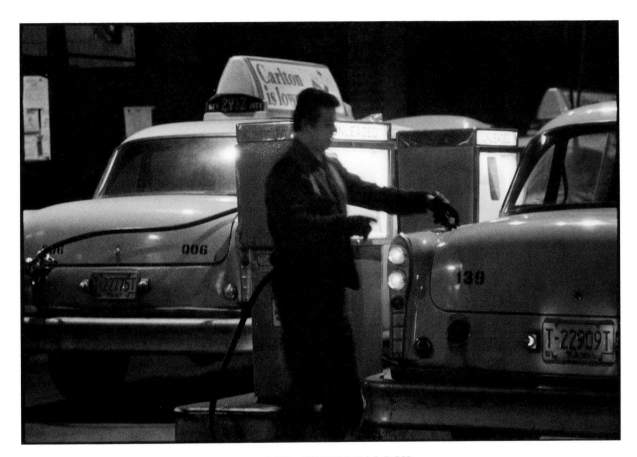

FREDDIE—NIGHT GAS BOY

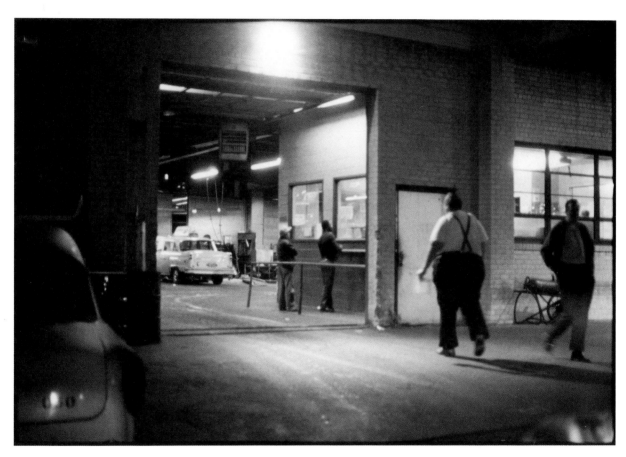

TO THE CASHIER'S LINE

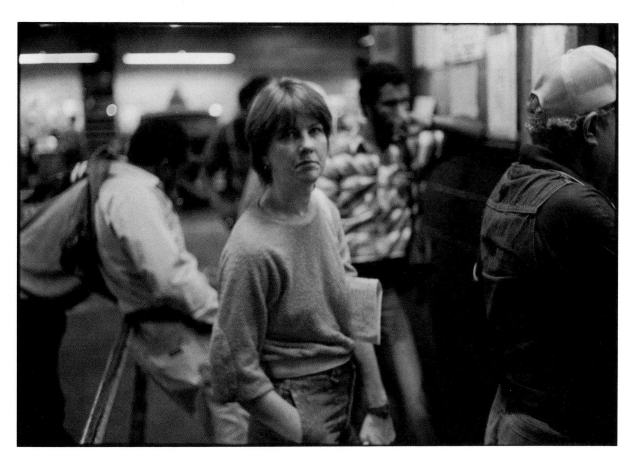

TERRI GABEL ON LINE

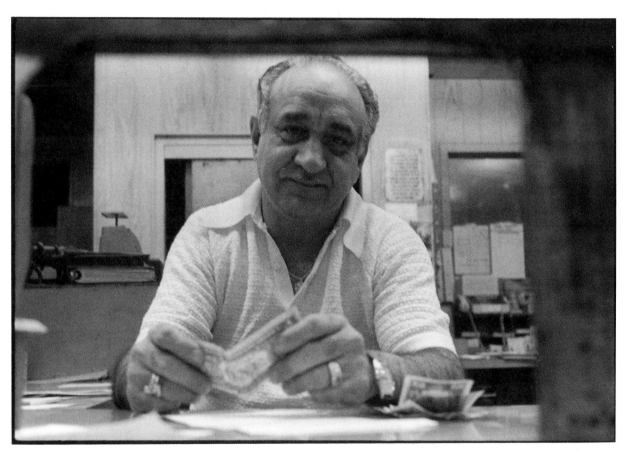

TONI—NIGHT CASHIER

JONATHAN—SKETCHING

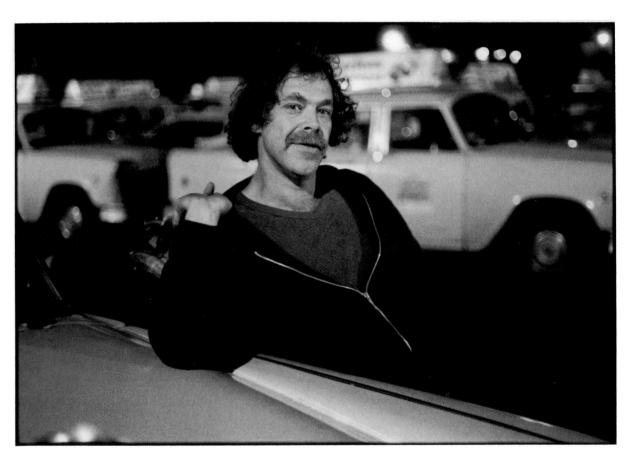

SHELLY

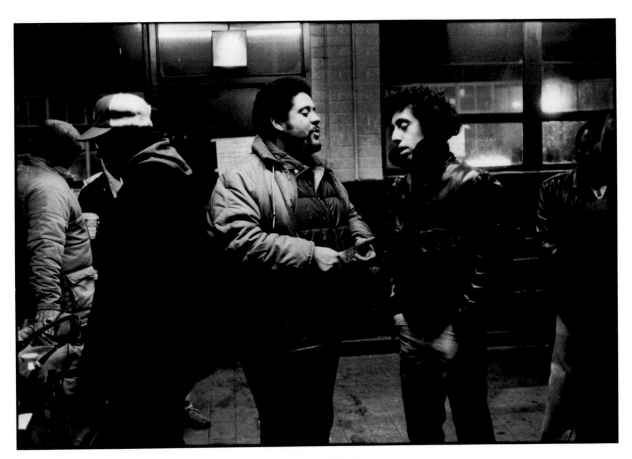

END OF SHIFT

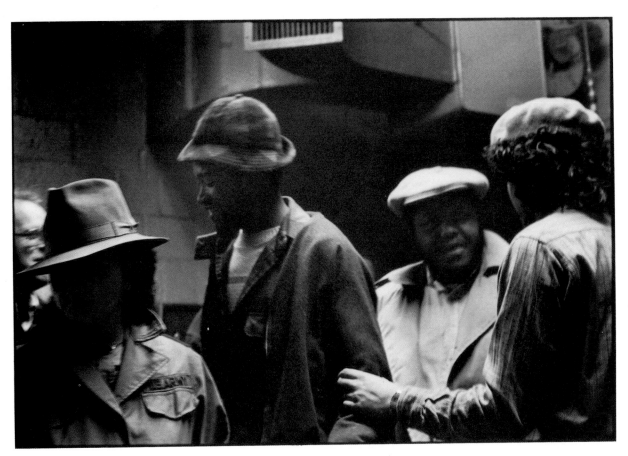

FOUR DRIVERS IN HATS

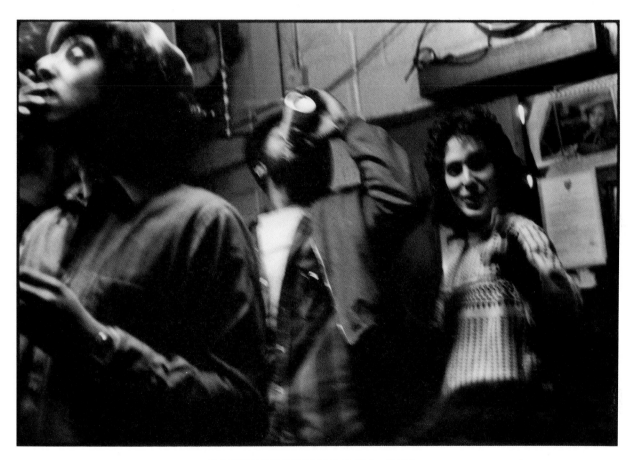

IN THE DRIVERS' ROOM—5AM

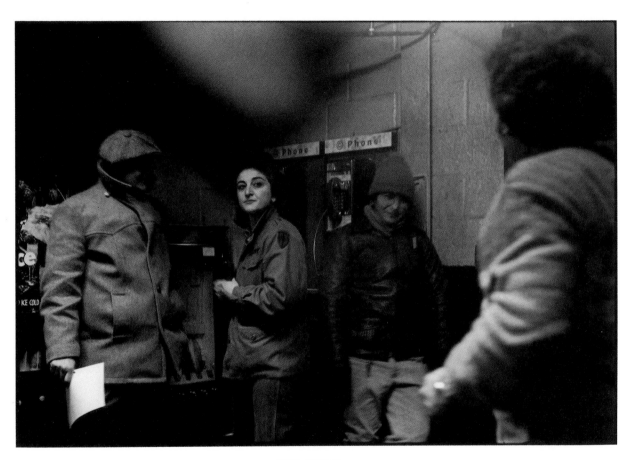

ICE COLD

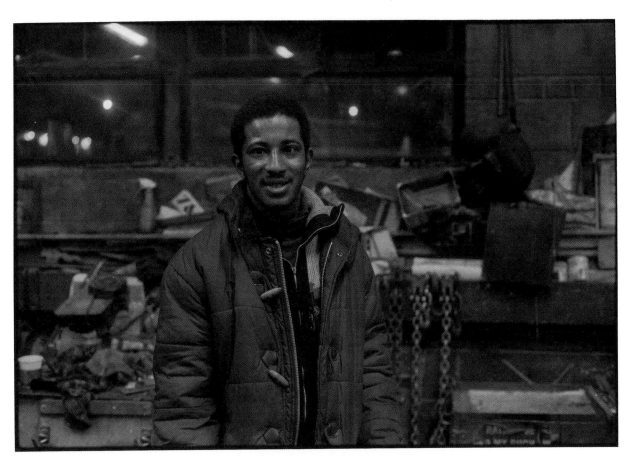

A NIGHT WASH BOY

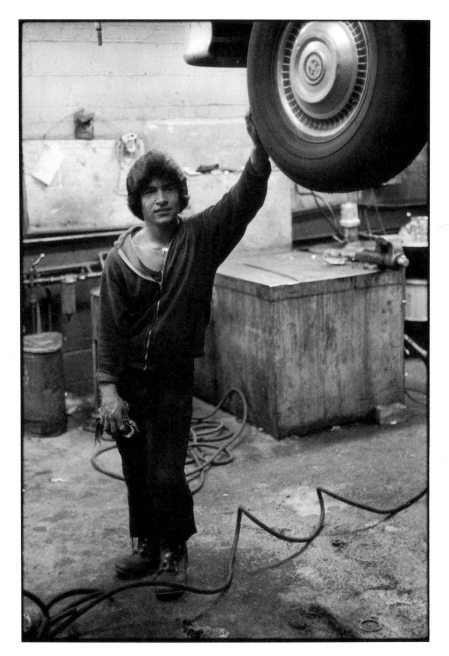

THE NIGHT MECHANIC

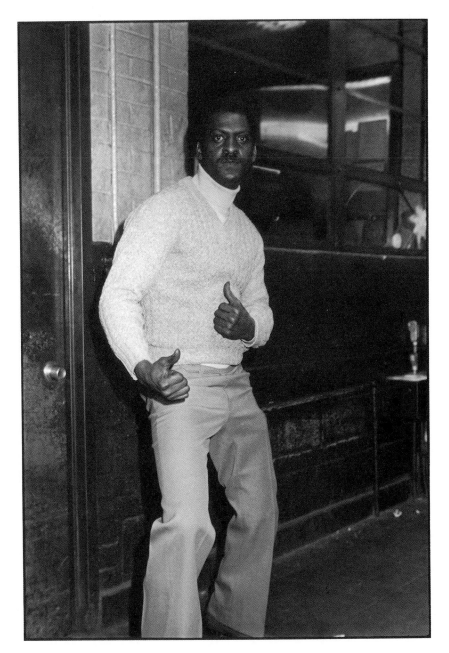

JAMAICAN CHARLIE

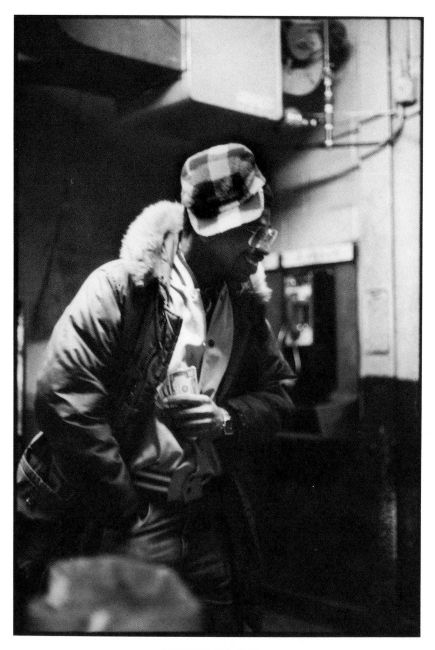

KENNY W/ 10'S

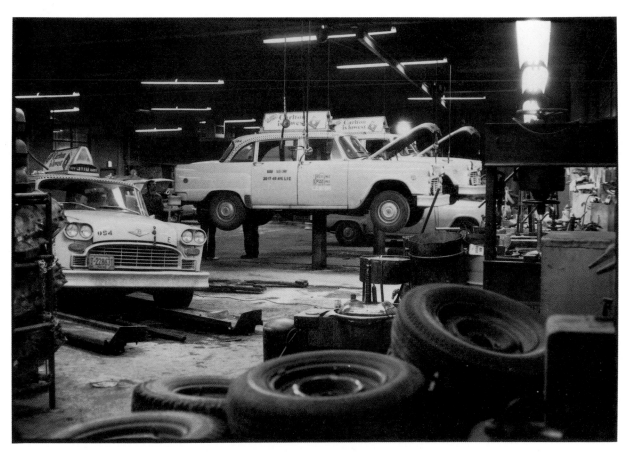

NIGHT REPAIRS

AFTER THE RAIN

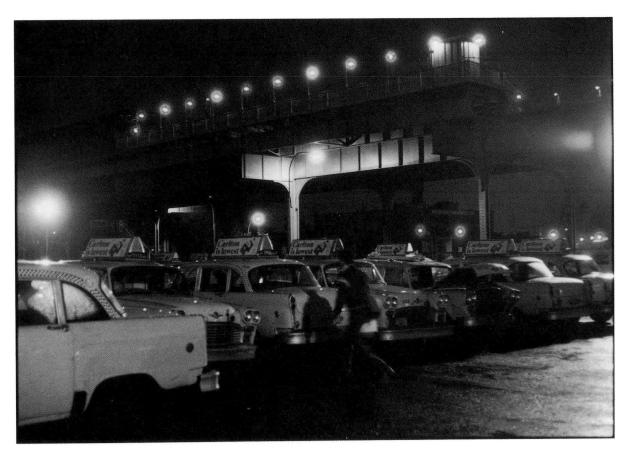

A DAY MAN GOING OUT

JUST AFTER DAWN

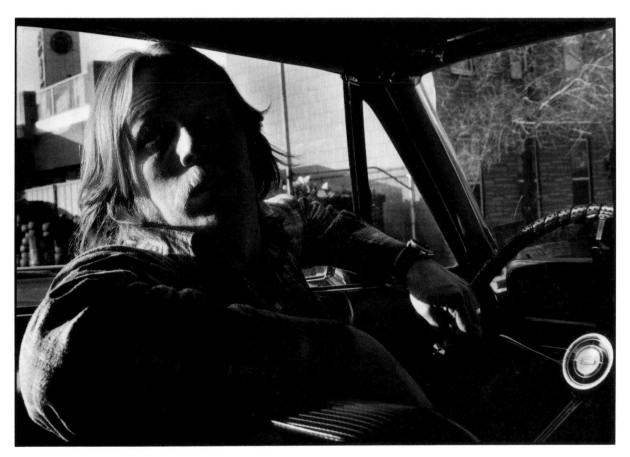

BILLY AT 5AM

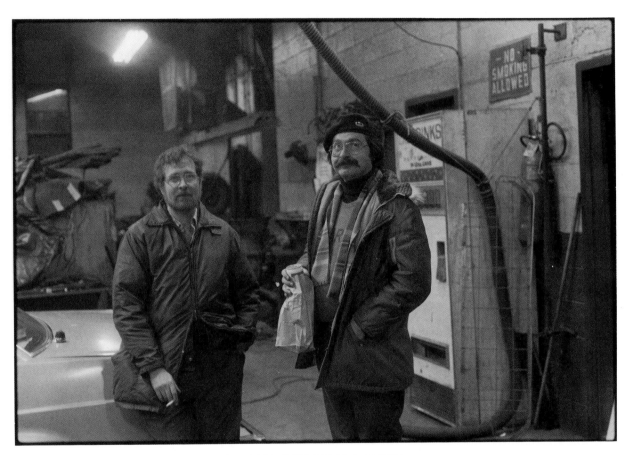

JIM AND VIETNAM DANNY

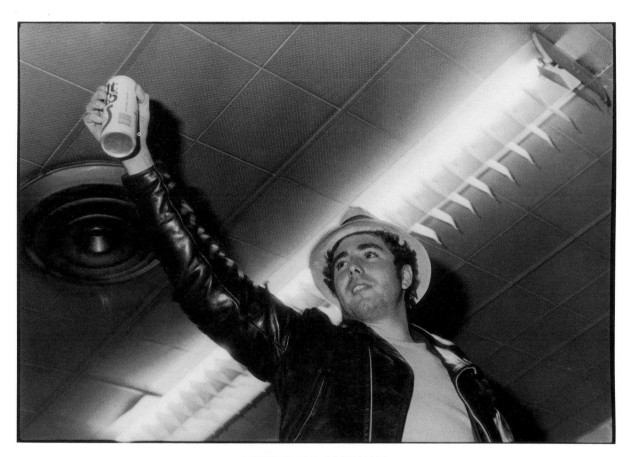

MULVIHILL SALUTAT.